IMAGES
of America

AFRICAN AMERICANS
OF SANFORD

To Helen (Stucke) +
Allen Stucks)
Thanks to the "black press"
we meet. What a blessing
your stories are fascinating to me
Valerie S. Dudley
April 17, 2015

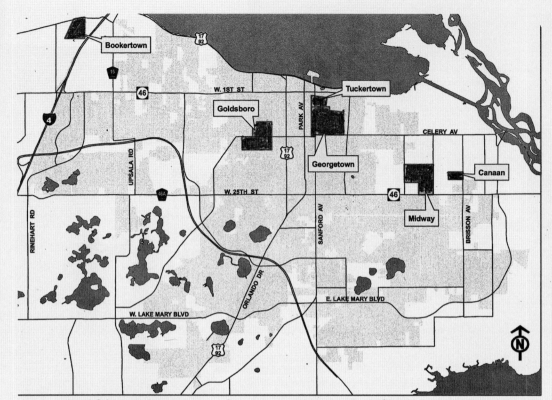

Historic African-American Communities in Sanford

This map shows the communities of Georgetown, Goldsboro, Bookertown, and Midway Canaan. (Courtesy of City of Sanford.)

ON THE COVER: The dedication of the Crooms Memorial Library was a much anticipated and celebrated event for African Americans in Sanford. Principal Joseph N. Crooms called it "a splendid achievement in bringing a better day to Negro youth in the development of individual thinking and advancement of the ethical and social progress of our people." The fund-raising efforts for the library reached out to alumni across the globe and garnered the support of both black and white citizens and business owners. Rev. Benjamin Hodge turned the first piece of soil at the dedication as Professor Crooms, his wife, Wealthy (back cover), Ireta Martin (far left), and Natalie Crooms (center), along with other members of the faculty and student body, stood with him. The library was a physical representation of the value placed on education in the African American community. The harsh Jim Crow laws made African Americans unwelcome at public libraries. Local photographer Willie "Pocket" Brown took this photograph. (Courtesy of Willie "Pocket" Brown family.)

IMAGES *of America*

AFRICAN AMERICANS OF SANFORD

Valada Parker Flewellyn and
the Sanford Historical Society

ARCADIA
PUBLISHING

Published by Arcadia Publishing
Charleston SC, Chicago IL, Portsmouth NH, San Francisco CA

Printed in the United States of America

Library of Congress Control Number: 2009922508

For all general information contact Arcadia Publishing at:
Telephone 843-853-2070
Fax 843-853-0044
E-mail sales@arcadiapublishing.com
For customer service and orders:
Toll-Free 1-888-313-2665

Visit us on the Internet at www.arcadiapublishing.com

CONTENTS

ACKNOWLEDGMENTS

A most sincere thank-you goes to the following: Alicia Clarke; the Sanford Museum, City of Sanford; EYESEEIMAGES; the Student Museum; Shirley Muse; the *Sanford Herald*; Gene Kruckmeyer; Tommy Vincent; the Zora Neale Hurston Institute for Documentary Studies; Anthony Major; Christine Kinlaw-Best; Jim Robison; Irma Copper; Daphne Francis Humphrey; Dorothea W. Fogle; Christine Dalton; Mike Jones; Sally Crooms Richmond; Beverly Brown; Claudia Brown; Martha Hall Doctor; Claudette Clark Hutchinson; Patty Swann; Bette Skates; Karen Jacobs; the Seminole County Museum; Kim Nelson; Brandi Wilmot; Willie Albert and Elizabeth Saunders; Charlie Carlson; James and Virginia Wilson; Vivian Hurston Bowden; Dr. Clifford Hurston Jr.; Sandra Duval McKinney; Victor Dargan; Tommy Webb; Merian Johnson; Shirley Allen; Carrie Sauls; Charlie Morgan; Vickie Brown Smith; Queen Esther Jones; Patricia Merritt Whatley; Jami Thomas; Marva Hawkins; Mary Fears; Jeanine Taylor; Earl E. Minott; Sheralyn J. Brinson; Cynthia Kendrick Walden; Thelma Mike; Sara Jacobson; Lorraine Offer, Ph.D.; Ollie Williams; Deacon Willie King Sr. and Willie King Jr.; Francis Coleman Oliver; Bill Toeves; Ricardo Gilmore; Juanita Green Gilmore; Tommy Webb; Rose Dunnum; Adelle Wilson Baker; Marilyn Martin; Ronald Nathan; Harry Harvey; Johnny Harvey; Rufus Brooks; Patricia Sherman; Edward Blacksheare; Aniah Rose English; "The Circle of Friends"; my most loved Fr. Nelson Pinder and Miriam; the late Irene Dixon; Carshena Baker; and the late Altermese Bentley. In your own unique way, you have all participated in making this publication possible. I am privileged to have each of you in my life, such a wonderful pool of support. I thank God for the opportunity to participate in bringing these beautiful images forward to be enjoyed for generations.

The support of my family is my most valued resource. My wonderful husband has worked hard to enable me to pursue my passions. I love you, Thomas. My skillful and talented children, Thomas III, Toya, and Tina, are always there for me. Toya missed a very special event to help me meet my deadline. I am so grateful. To my dear Dorothy T. Johnson, a mother, a mentor, a friend, along with Royce and Eddye Kay Walden and Virginia and James Wilson, you have all enriched my life so much. Thanks to my dear sister, Commissioner Toni Carter, Melvin, and my Minnesota family. Thanks to Aggie Whyte (my sister by heart); Lorelei, Clinton, and James Francis; Ida Law; Rhonda and Carlton Boston; Dorohn Frazier; Henry Simmons; and Tony, Brenda, Lance, Nicole, Kim, Thomas, and Barbara Flewellyn. Thanks to Rosa Lang Payne, Lulee Speights, Juanita Windham, Henry and Darryl Windham in Alabama, and this is in loving memory of Icabod Flewellen, the "Father of the African American Museum," who made African American history meaningful for me and countless others. May theses images inspire the viewer to treasurer every moment and pause to capture some.

On behalf of the Sanford Historical Society and its board of directors—Walter Smith, president; Valada Parker Flewellyn, vice president; Pauline Routh, secretary; Grace Marie Stinecipher, membership secretary; Joe Hunt, treasurer; and directors Christine Kinlaw-Best, Stan Rockey, Connie Williams, and Paul Hodgins—thank you.

INTRODUCTION

The first African Americans arrived in the Sanford area prior to the Seminole Wars of the 1830s. Sanford was founded after the Civil War and incorporated in 1877. Georgetown, Bookertown, Goldsboro, and the Midway/Canaan communities were settled shortly after the Civil War. These communities provided a much needed labor pool for the growing vegetable and citrus industries in Sanford's postwar development. These industries gave rise to the ice, packing, shipping, and railroad industries needed to support them. In addition to working as laborers in these industries, many African American entrepreneurs opened businesses, along Sanford and Celery Avenues in Georgetown, Thirteenth Street in Goldsboro, and Sipes Avenue in Midway, to support the growing black population and to offset the effect of segregation on their daily lives. This gave rise to two very divided yet bustling communities, one black and one white, side-by-side, one paying very little attention to the other except for areas in which there was fear or dependency. In spite of the white community's economic advantage, its dependency on African American labor was substantial both at work and at home. Over the years, Sanford grew; however, there was little evidence of that growth seen in the black communities. During the many years when African Americans were denied equal access to public facilities, businesses sprang up in the community to meet its needs and often to service the white community as well. Great food and entertainment drew white patrons to restaurants and clubs in the black business district, providing great opportunities for entrepreneurs and entertainers. Integration changed that dynamic, and residents saw the gradual decline of the communities as access to public facilities that had been "white only" were legally obliged to service blacks. Creative Sanford, Inc., is a local nonprofit organization that is currently collecting the stories of Seminole County and Sanford residents from a variety of multicultural and socioeconomic backgrounds in order to pen them into folk plays that will be performed by volunteers from the community. These stories, like the images you will see here, give us insight that can help us to better shape the way we live together in the future.

Americans are more interested and appreciative of African American history now than we have ever been because of the election of the first African American president. This is the dream we held fast to, the hope that lingered in our hearts. Americans are proud of what this election says about our ability to judge each other, as Dr. Martin Luther King Jr. suggested, "not based on the color of our skin but by the content of our the character." Books like this one have an even greater significance as we work together to collect and preserve the treasures of our collective history, in order to better understand and appreciate each other. This beautiful collection of images reflects the efforts of the whole Sanford community; people of every race and every ethnicity have made some contribution to this fine work. God bless America!

Bokey [Bo-key]
by Valada Parker Flewellyn

From Bookertown to Canaan Land
March me in the "Panther" band
A stroll down Sanford Avenue
Sugarcane on Sipes to chew

Baptize me in the water
Move me from the Quarter
Dun pee'd on a rug
Drank cider outa jug

Danced at the jook joint
Sang in the pew
Love everybody
Christian, Muslim, Jew

Put words in the mouth
Of Mohammed Ali
"Float like a butterfly
Sting like a bee"

Hit a ball out of the park
Swam with an alligator
Ate me sum shark
And I ain't afraid of the dark

Are you?

"Bokey" is an endearing term used by the migrant fruit and vegetable pickers when referring to their return to Sanford; they would say, "I'm going back to Bokey."

One

GEORGETOWN

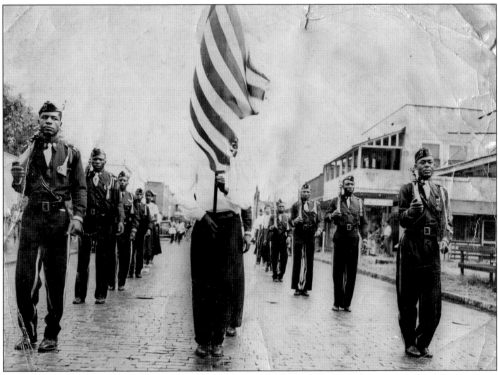

The America Legion Auxiliary marches in a parade down Sanford Avenue in the Georgetown neighborhood. Founded by Gen. Henry Sanford in 1870, Sanford became the "Gate City of South Florida." The first African Americans had come to the area prior to the Seminole Wars of the 1830s. When Sanford arrived, he attempted to use black laborers in his groves but was discouraged by the violent reaction of some locals. In response to the violence, he created Georgetown, a neighborhood with its own commercial district, which encouraged the rise of a black middle class in the city. A total separate business district developed to meet the needs of the African American community. Teachers and other professionals built homes on Sanford, Cypress, and Locust Avenues. There were plenty of jobs, and the community pulled together in order to shield itself from the harsh reality of Jim Crow and the threat of the Ku Klux Klan. The 1960s brought about change. School integration was ordered, and in 1968, the children were the first to test the climate of this new equality, as they were moved from their community schools to white public schools. This marked the beginning of a reshaping of the community. (Courtesy of Willie "Pocket" Brown family.)

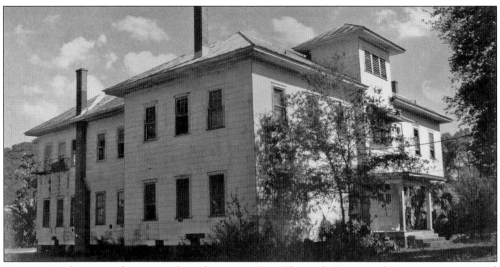

Hopper Academy was first erected on this site at East Eleventh Street and Pine Avenue around 1903 as the second home of Hopper Academy and the high school for Sanford's African American community. The building was expanded in 1916. The original "colored school" was at Seventh Street and Cypress Avenue and included grades 1–10. The first principal was a Mr. William C. McLester. The new school building was constructed under principal Joseph N. Crooms, and the old school became an elementary school. This building continued as a high school until the construction of Crooms Academy on the west side of town in the community of Goldsboro. Today inside Hopper Academy is the African American Museum of Sanford, founded by lifetime resident and collector Frances Coleman Oliver. (Courtesy of Georgetown Collection, Student Museum.)

PROGRAM

1. Processional
2. "Asleep In Jesus" Choir
3. Prayer .. Rev. A. F. Smart
4. Scripture Reading Rev. A. M. Means
5. Selection—"Well Done" Choir
6. Sister Crooms As Neighbor and Friend"
 Mrs. L. Arrington
7. Selection Missionary Quartte
8. As A Religious Worker in Church and State
 Mrs. V. T. Hill
9. Favorite Song—"Jesus Paid It All" ... Mrs. N. A. Green
10. Acknowledgement of Telegrams, Letters, Resolutions
 and Cards of Condolence Mrs. A. M. Means
11. Testimony of the Family Rev. A. C. Crooms
12. Obituray Mrs. Esther Lancaster
13. Remarks Rev. T. C. Colyer and visiting Pastors
14. Favorite Hymn—"My Hope Is Built On Nothing Less"
 Choir
15. Eulogy Rev. Robert L. Jones
 St. Augustine, Fla.
16. House Hold of Ruth Ceremony
17. Woodman Ceremony
18. Recessional.

Mrs. Daphney Crooms

It can be truly said that, in the training of her family, in the church and in the social circle, she always did her duty nobly. Ripened in years, and fully prepared for another state of existance, she passes on now to enjoy the reward of a life well spent on earth.—*The Family*.

This is the obituary of Daphne Crooms, the mother of Joseph N. Crooms. Professor Crooms developed the first secondary school for African Americans in Seminole County in 1926. He contributed the land and was the first principal. His wife, Wealthy, was assistant principal and became the principal when her husband died. The Crooms family offered a curriculum that expanded past the agricultural and industrial training present in most black schools at that time. Professor Crooms offered more academic work to prepare his students for higher education. (Courtesy of Sally Crooms Richmond.)

This is the Hopper senior class in 1923. Seated on the right is James A. Walden, son of a former mayor of Goldsboro, Albert Walden. After graduating from Crooms Academy, James attended Florida Agricultural and Mechanical College for Negroes in Tallahassee. (Courtesy of Royce and Eddye Kay Walden.)

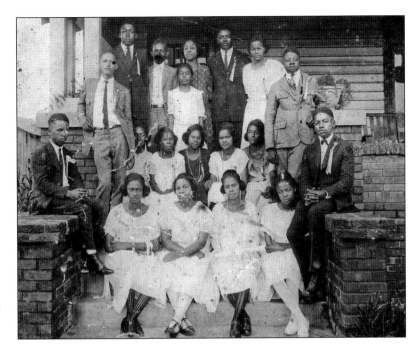

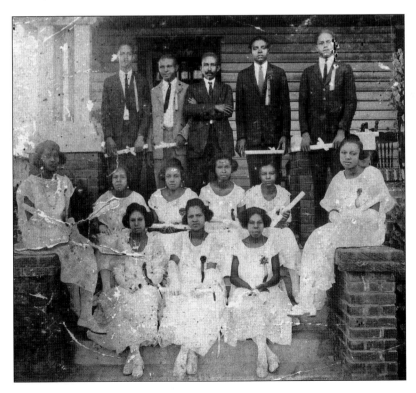

This is the Hopper Academy senior class of 1924. Seated on the right pillar is Vivian Jackson, daughter of William "Page" Jackson. Vivian married James Walden (above). (Courtesy of Royce and Eddye Kay Walden.)

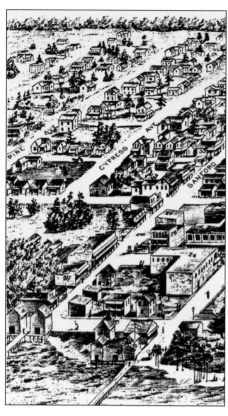

A bird's-eye view of the Georgetown section of Sanford was taken from a drawing by H. S. Wyllie in May 1890. (Courtesy of Georgetown Collection, Sanford Museum.)

Henry Shelton Sanford founded the city of Sanford in 1870 and set aside a portion of the city, named Georgetown, for the black community. Sanford and Cypress Avenues became the primary commercial areas for the town and the corridor for teachers, entrepreneurs, and businesses. Henry Sanford served as a U.S. diplomat to Belgium. He was present at the Berlin Conference, which resulted in the dividing of the continent of Africa between the European colonial powers. He was a close friend to many abolitionists. He had great respect for the African Americans as laborers and as intellectuals. He felt that their experience as the African in the United States made them superior to their countrymen from Africa and, therefore, on their return to Africa they could civilize and regenerate the parent country. (Courtesy of the Sanford Museum.)

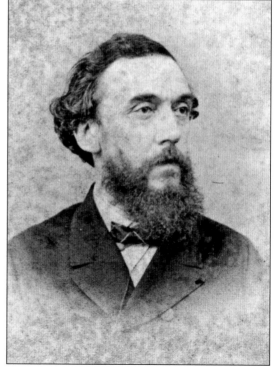

This is Rev. Adaway A. Fields (1890–1978), an active member of the Sanford community. He was married to Henrietta and lived at 921 West Eleventh Street. In the 1920s, Reverend Fields worked as a fireman for the Atlantic Coast Line Railroad and received a commendation for his great work. (Courtesy of Royce and Eddye Kay Walden.)

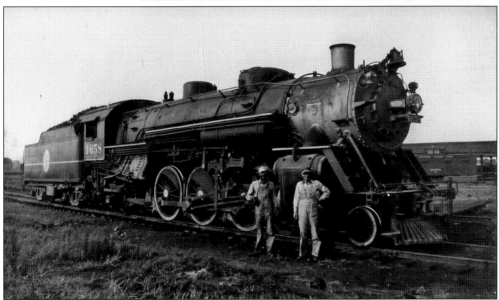

This is Engine No. 1658 on the Atlantic Coast Line Railroad. This engine was referred to in a letter of commendation to engineer E. McConnell and fireman A. A. Fields (above) dated April 9, 1921, from the superintendent; it reads: "Mr. Stevens advises me that on April 7 you brought Extra 1658 into Sanford with cylinder packing gone on both sides and a heavy train of 76 cars; in other words you brought in a full tonnage train without delay. This is very fine work and [I] have to compliment you and your fireman on what you did in avoiding an engine failure, which might have had disastrous consequences." (Courtesy of Georgetown Collection, Student Museum.)

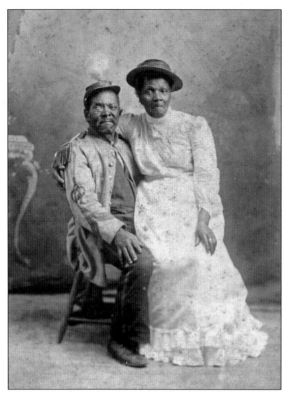

This is a photograph of Adam Shadrach and his wife, Rachel. Adam "Old Shad" was Sanford's official gunner. He fired the city cannon, "Beelzebub," on all official occasions, such as President Grant's visit for the ground-breaking for the South Florida Railroad in 1880. Shad was born a slave in South Carolina and served in Battery G, 2nd Light Artillery, of the U.S. Colored Troops in the Civil War. "Beelzebub," the old cannon he had fired so many times, blew apart during celebrations for the creation of Seminole County, two years after his death in 1911. The barrel of the cannon now serves as a base for the flagpole at Sanford's chamber of commerce. (Courtesy of the Sanford Museum.)

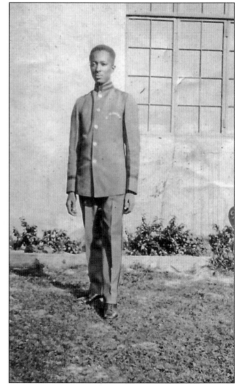

The young man in this picture worked as a porter for the railroad in the 1930s. (Courtesy of Daphne Francis Humphrey.)

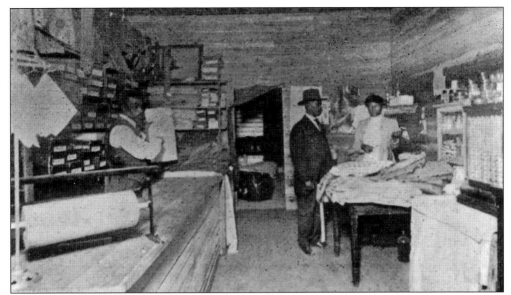

Sanford Avenue was a center of commercial activity in the African American communities. This is King Solomon Johnson's dry goods store. Johnson and his wife, Lizzie, resided nearby at 408 Cypress Avenue. They owned a number of nice properties in Sanford. Johnson came to Sanford around 1904 and opened his store and an undertaking business. Lizzie Johnson gave music lessons in their home. They were members of St. James African Methodist Episcopal Church. (Courtesy of the Sanford Museum.)

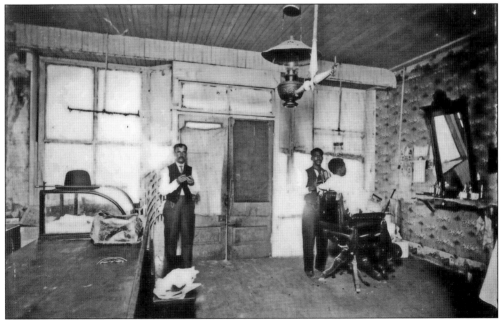

This is the barbershop of Frank Edward Eaverly, located at 110 Sanford Avenue in the 1880s. It was one of six "colored" barbershops listed in the directory in 1909. Eaverly was also in the watch and jewelry repair business. He and his wife, Julia, had two daughters. Jennie was a seamstress in partnership with Mamie Dorsey in the Dorsey and Eaverly Millinery Shop, and Julia was a teacher at Hopper Academy. (Courtesy of the Sanford Museum.)

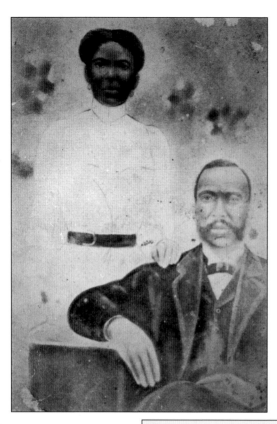

This is a portrait of John and Lucy Potts Hurston. Reverend Hurston was pastor of Zion Hope Missionary Baptist Church in the early 1900s. He was born in 1861 in Notasulga, Alabama. Lucy Potts and children Hezekiah Robert "Bob," John, Richard, Sarah, Zora, and Joel were all born in Alabama. Benjamin "Ben" and Everett were born in Florida. The Hurstons lived in Eatonville until after the death of Lucy Hurston in 1905; John Hurston remarried and moved with his wife, Mattie Moge, to Georgetown. (Courtesy of Dr. Clifford Hurston and Vivian Bowden Hurston.)

The Zion Hope Missionary Baptist Church was founded in a brush arbor, a temporary structure made of sticks and palmetto fronds. Early services were held in an old horse stable on Mellonville Avenue. In 1890, the church moved to Fifth Street and Locust Avenue and in the early 1920s moved again to this location at 710 Orange Avenue. This sanctuary was opened on June 13, 1926, while Rev. H. W. Williams was the pastor. (Courtesy of EYESEEIMAGES.)

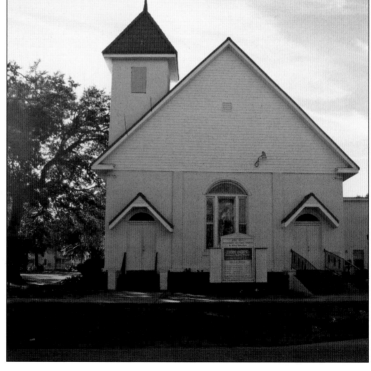

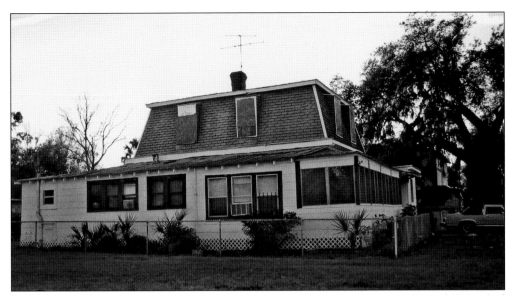

Rev. John Hurston purchased this home at 621 West Sixth Avenue around 1905. He left Sanford to pastor a church in Jacksonville in 1916, and midwife Corrie Jones purchased the house. Corrie's daughter Marie Francis left her husband and moved from Sarasota, Florida, with her baby, Daphne. Marie went to school to learn midwifery and operated the Francis Maternity Home out of the house. The house is a landmark in Georgetown. Over 40,000 babies were delivered here. It is now referred to as the Hurston/Francis House. (Courtesy of Daphne Francis Humphrey.)

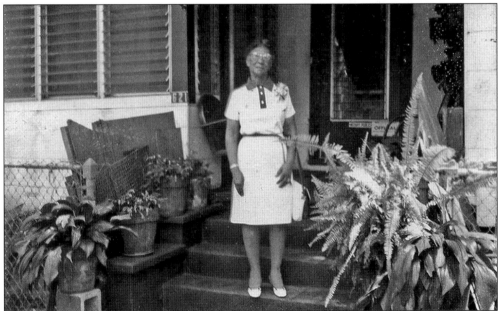

Marie Jareina Jones Francis (1906–1988) stands on her porch at 621 West Sixth Avenue. The daughter of Walter and Corrie Bailey Jones, she was born in Dublin, Georgia, moved to Sanford in 1917, and later moved back from Sarasota in 1942. She and her mother opened a midwife service here together. They delivered more than 40,000 babies. She delivered babies in and around Sanford for 30 years. She has two daughters, Daphne F. Humphrey and Cassandra G. Clayton, and a granddaughter, Amber Marie Clayton. (Courtesy of Daphne Francis Humphrey.)

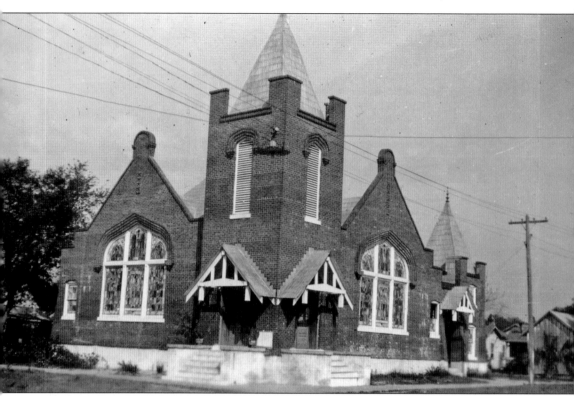

The historic St. James African Methodist Episcopal Church was founded in 1867 in an old house on Mellonville Avenue. In 1880, the church purchased land at the northeast corner of East Ninth Street and Cypress Avenue (819 Cypress Avenue) from Gen. Henry Shelton Sanford's Florida Land and Colonization Company. Church services were conducted in a brush arbor at the east end of the lot until 1881. A small wood-frame building was erected under the guidance of the first pastor, Samuel H. Coleman (1880–1884). The church was then known as St. James Chapel. The first building was replaced in 1893 with a larger wooden structure under the leadership of Rev. Teadoes T. Gaines. The planning and construction of the present red-brick structure with four matching stained-glass windows, a bell tower, and a slanted semi-circular seating in the baptistery was by African American architect Prince W. Spears. The building was constructed under the leadership of Rev. William H. Brown, who died before the church was completed. St. James served as the mother church in the 1920s and 1930s, sending circuit preachers to West Sanford, Bookertown, Cameron City, Midway, and Fort Reid. (Courtesy of Georgetown Collection, Sanford Museum.)

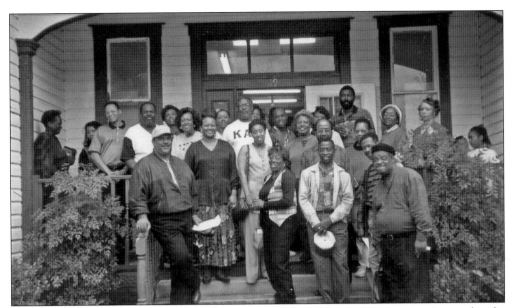

Students, family, board members, and friends of the Tajiri School of Performing Arts gather for a photograph on the porch of the school, founded by Patricia Merritt Whatley. The building was the Sanford Primary School, formally referred to as "The Little Red School House," and was the elementary school for white children. Black children attended Hopper Academy. The building is located at 519 Palmetto Avenue in Georgetown. (Courtesy of EYESEEIMAGES.)

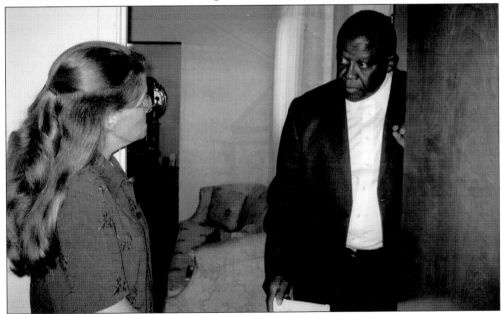

Christine Kinlaw Best, researcher and president of the Sanford Museum Advisory Board, visits Bernard Mitchell at the Wilson Eichelberger Funeral Home after spending an afternoon doing research at the Page Jackson cemetery. Christine and Alicia Clarke, curator at the Sanford Museum, have been a tremendous aid to Charlie Morgan, Charlie Carlson, Altermese Bentley, Valada Flewellyn, and a number of other authors who write about blacks in Florida. (Courtesy of Valada Parker Flewellyn.)

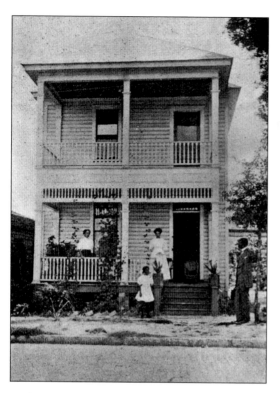

This is the Harris Nest, the home of Frank and Montez Harris in the early 1900s. It is located at 407 East Second Street. The house was purchased by a nonprofit organization, Golden Rule, from the United Negro College Fund. (Courtesy of Frank and Montez Harris Collection.)

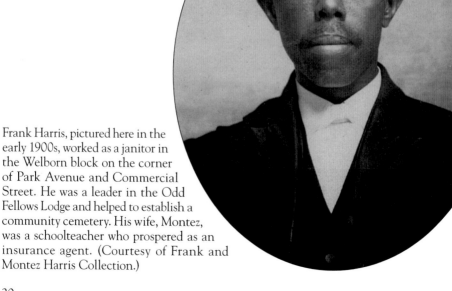

Frank Harris, pictured here in the early 1900s, worked as a janitor in the Welborn block on the corner of Park Avenue and Commercial Street. He was a leader in the Odd Fellows Lodge and helped to establish a community cemetery. His wife, Montez, was a schoolteacher who prospered as an insurance agent. (Courtesy of Frank and Montez Harris Collection.)

Mabel J. Hurston was born in Montgomery, Alabama. She was married to Clifford J. Hurston Sr. They had two children, Clifford Jr. and Vivian. She was a teacher and a librarian in the Seminole County Public Schools. She was a member of St. James African Methodist Episcopal Church, Alpha Kappa Alpha Sorority, Inc., and many educational organizations. She died at her home on Sanford Avenue on May 17, 1980. (Courtesy of Dr. Clifford Hurston Jr. and Vivian Hurston Bowden.)

Clifford Hurston Sr. is the son of Rev. John and Lucy Potts Hurston. Shortly after the death of his mother in 1905, Clifford lived with Joseph and Wealthy Crooms at their home on Sanford Avenue. After graduating from Hopper Academy, Clifford went away to finish high school. He obtained his master's degree from Columbia University. After working as a principal in Alabama, he returned to Sanford with his family and purchased the Crooms home in 1954. He taught math at Crooms Academy. (Courtesy of Dr. Clifford Hurston Jr. and Vivian Hurston Bowden. (Courtesy of Dr. Clifford Hurston Jr. and Vivian Hurston Bowden.)

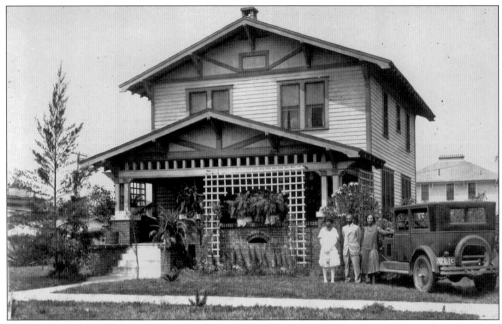

This is the Crooms/Hurston house. Joseph and Wealthy Crooms are pictured with their daughter Wealthy next to the family car. The Crooms family sold the home to Clifford Hurston Sr., the brother of Zora Neale Hurston in 1954. Their father, John Hurston, helped build the house. (Courtesy of Dr. Clifford Hurston Jr. and Vivian Hurston Bowden.)

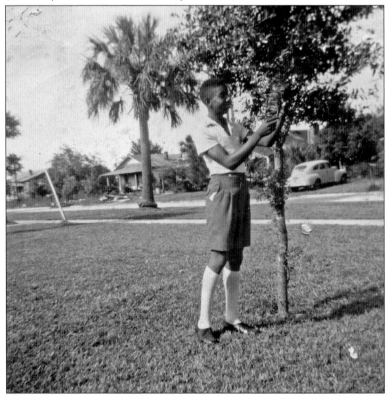

Clifford Hurston Jr. observes the trees in the front yard of the family home. This picture was taken in June 1955. Clifford Hurston Jr. returned to Georgetown with his family after living in Alabama. (Courtesy of Dr. Clifford Hurston Jr. and Vivian Hurston Bowden.)

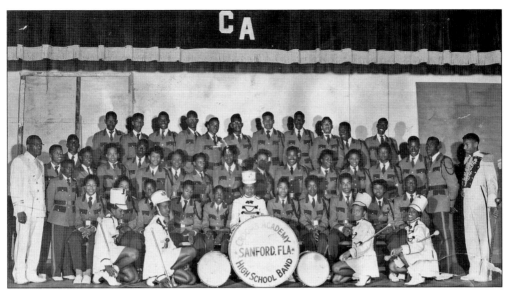

The Crooms Academy Band is pictured here in 1955. (Courtesy of Dr. Clifford Hurston Jr. and Vivian Hurston Bowden.)

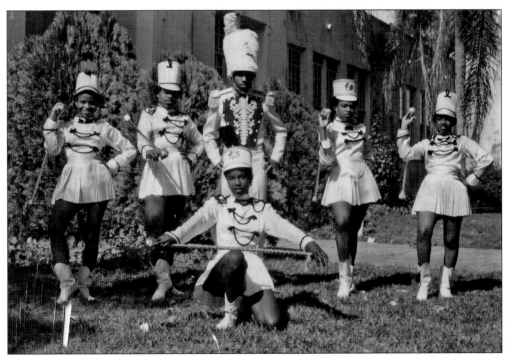

The Crooms Academy majorettes pose with drum major Clifford Hurston Jr. (back row center) in 1955. (Courtesy of Dr. Clifford Hurston Jr. and Vivian Hurston Bowden.)

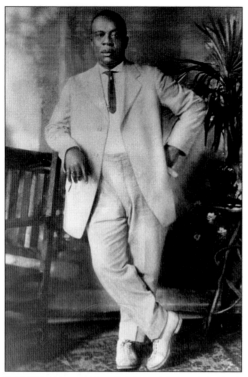

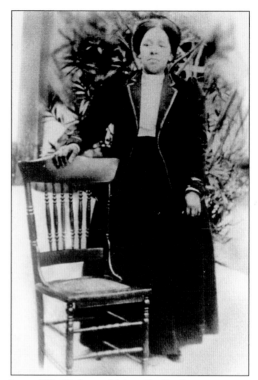

James W. Hicks and his wife, Emily Barrington Hicks, are pictured above. James was a carpenter. Their daughter Julia was one of the first beauticians in Sanford, and their son John H. Hicks became an undertaker. Their other children were Jefferson, Abraham, Silva, Marie, Jesse, and Frank. The Hicks family resided at 709 Cypress Avenue. (Courtesy of Georgetown Collection, Student Museum.)

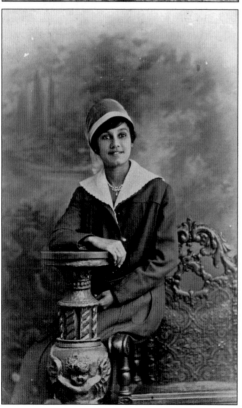

This c. 1920s portrait was found in the home of Frank and Montez Harris, the Harris Nest. The woman is unidentified. (Courtesy of Frank and Montez Harris Collection.)

Famed anthropologist and author Zora Neale Hurston resided in Sanford during the time she wrote two of her books: her first novel, *Jonah's Gourd Vine*, and *Mules and Men*. Zora (center) is on the lawn with her nieces and nephews. From left to right are Wilhelmina, Pie-Pie, Edgar, and Zora's brother Ben's dog, Prince, in 1934. (Courtesy of Dr. Clifford Hurston Jr. and Vivian Hurston Bowden.)

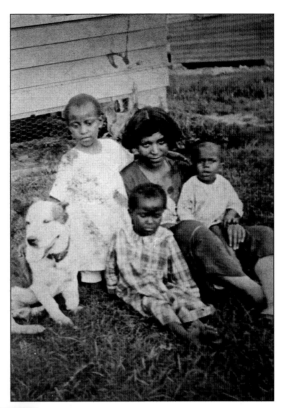

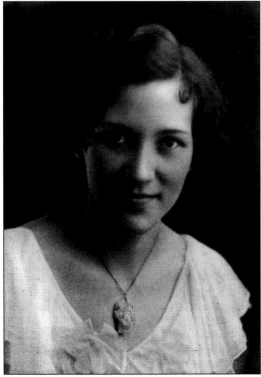

Mildred Knight (Walton) typed the manuscript for two of Zora Neale Hurston's books, *Jonah's Gourd Vine* and *Mules and Men*. This picture was taken around that time in 1934. Zora mentions Knight in her autobiography. Mildred visited the museum in 2006 and was interviewed by Valada Flewellyn. (Courtesy of Mildred Knight Walton and the Sanford Museum.)

Four-year-old Martha Hall is the daughter of Early Hall and Mary Dunaway Hall. She was born in Sanford on March 15, 1934. Martha attended Goldsboro Primary School (called the Little Red School House) and graduated as an honor student from Crooms Academy in 1952. (Courtesy of Martha Hall Doctor.)

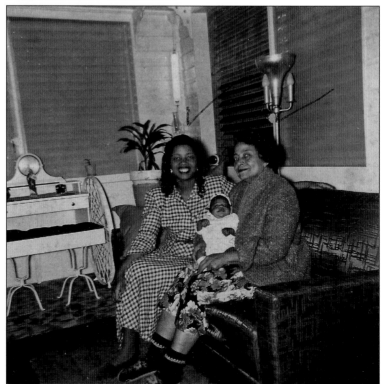

Juanita Green Gilmore brings her new baby son Ricardo to visit Ola Brock. (Courtesy of Juanita Green Gilmore.)

Sisters Ingrid Burton Nathan (left) and Patricia Sherman (right) stand outside the Zion Hope Missionary Baptist Church after the Friends and Family Day celebration to honor the long-standing members of the church; their mother, Cleo "Miss Cleo" Burton, was among the honorees. Miss Cleo's beauty shop is the longest continually operating shop in Sanford's history. Miss Cleo is 89 years old and still operates her beauty shop. (Courtesy of EYESEEIMAGES.)

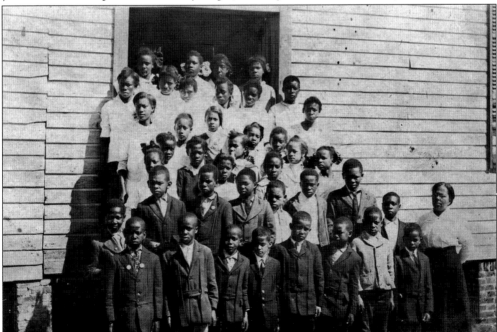

Montez Harris and her students pose outside of the old Hopper Elementary School that was located on Seventh Street and Cypress Avenue before moving to the present location on Pine Street. (Courtesy of Georgetown Collection, Student Museum.)

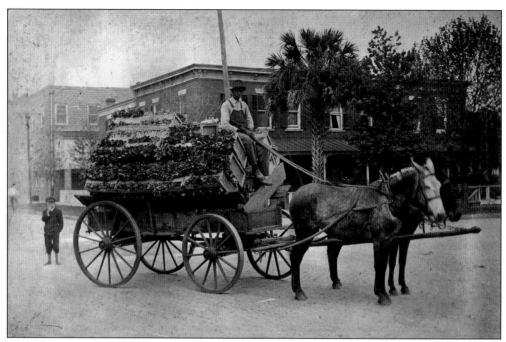

William Taylor, a drayman, is driving his celery wagon along Second Street. He worked for celery farmer O. J. Pope. The young boy behind the wagon is Fred Pope, son of the farm owner. (Courtesy of the Sanford Museum.)

Things do erupt occasionally in the streets of Georgetown; however, thanks to the fine workers in the city's public works department, the problems are temporary. This photograph was taken in November 1999. (Courtesy of the Sanford Herald Collection, Sanford Museum.)

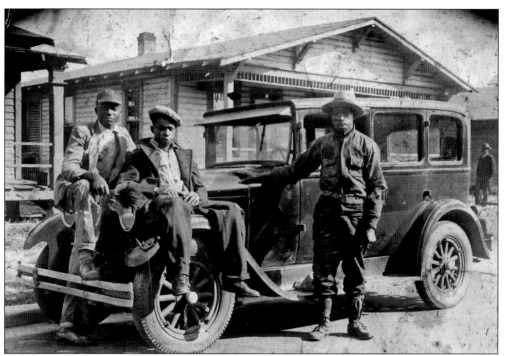

John J. Kinard (right) is pictured next to his car with two of his buddies in the 1920s. (Courtesy of the Sanford Museum.)

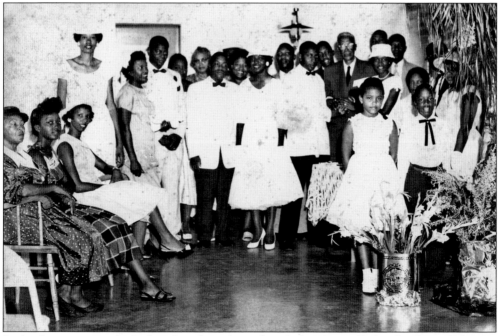

In this festive image, the little girl on the right is identified as Annye Refoe, daughter of Herman and Shelley Refoe. She is now Dr. Annye Refoe, dean of arts and sciences for Seminole Community College. The gentleman with the eyeglasses behind her is Reverend Hodge. Seated third from the left is Vivian Hurston. (Courtesy of Royce and Eddye Kay Walden.)

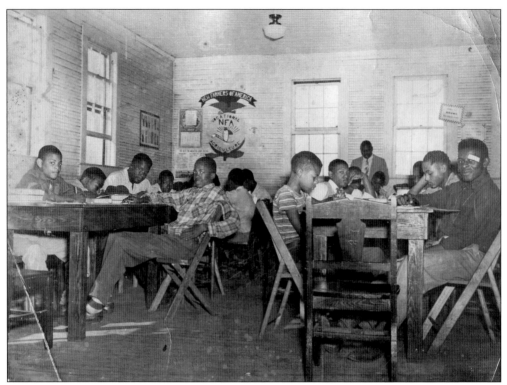

Pictured are members of the agricultural class at Hopper Academy in the 1950s. (Courtesy of Daphne Frances Humphrey.)

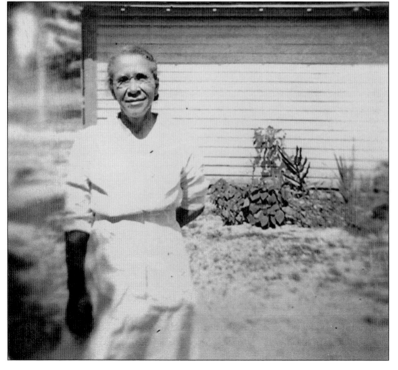

This is Corrie Jones, a midwife. She purchased the house at 621 West Sixth Street that belonged to John Hurston. She is the mother of midwife Marie Francis. Corrie worked for Dr. Julian Tolar before starting her own midwife business. Many students from the nearby school came to mentor under her. She is standing in her backyard. (Courtesy of Carrie Sauls.)

This is a self-portrait of local photographer Willie "Pocket" Brown. He was born and raised in Sanford. He married Julia Baldwin and had a studio on Sanford Avenue for over 40 years. Most of the church, school, social, and family events in Sanford were photographed by him. His photographs were featured in *Ebony* magazine in October 1953. His love for people and photography has helped to preserve the history and legacy of the black community in Sanford. Drew "Boudini" Brown (trainer for Mohammed Ali and the man who wrote most of world champion Ali's famous lines) is his cousin. Boudini also lived in Sanford. Willie Brown passed away in 1987, but his family still resides in Sanford and continues his entrepreneurial tradition. His daughter Beverly Brown owns a barbershop on Sanford Avenue. His daughters Claudia and Beverly have compiled an exhibit of his photographs. (Courtesy of Willie "Pocket" Brown family.)

Julia Baldwin Brown is the widow of Pocket Brown. She owned and operated a beauty salon next to her husband's photography studio on Sanford Avenue for many years. Her husband took this portrait. (Courtesy of Willie "Pocket" Brown family.)

The true spirit of Julia Baldwin Brown (seated) is seen in her eyes and her smile; she has been a resident of Georgetown for many years. As a mother, a Christian, a loyal friend, and supporter of youth, she has offered her house as a safe haven for neighborhood children. She was a trained cosmologist, and her chair was a place of comfort and rest for her clients. Behind that smile is kept the memories, secrets, and dreams of those who came to her. Her signature is an encouraging word and a smile. Her daughter Claudia (standing) is her caregiver. Claudia is a retired librarian. She moved back to Georgetown from New York and is currently writing a book of short stories about her memories of growing up in Georgetown. (Courtesy of Valada Parker Flewellyn.)

Photographer Willie "Pocket" Brown's family is at Muhammad Ali's training camp in Deer Lake, Pennsylvania. From left to right are (adults) James Brown, Gladys Saunders, Drew "Boudini" Brown, Julia Baldwin Brown, Dallas Brown (Willie's son), Vera Mills, Jackie Jones, and Willie Brown III; (children) Geju, Zaki, and Geju. (Courtesy of Willie "Pocket" Brown family.)

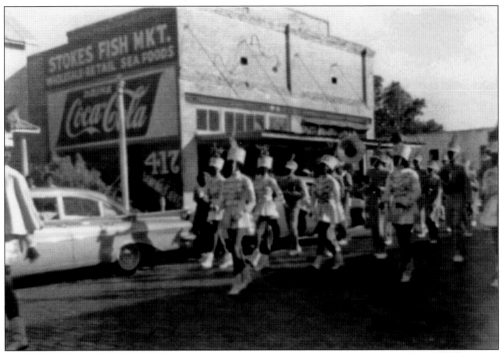

This photograph of the Crooms Academy Mighty Panthers marching down Sanford Avenue in the 1949 homecoming parade was taken by local photograph Willie "Pocket" Brown. (Courtesy Willie "Pocket" Brown family.)

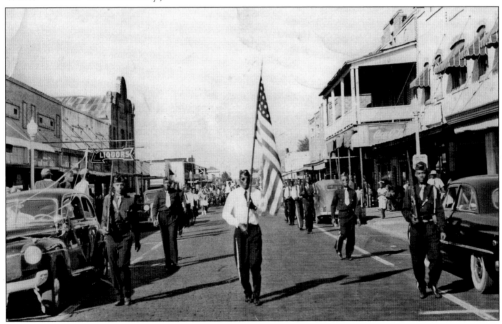

David N. Roberts Sr. is leading a military parade south on Sanford Avenue. The photograph shows what Sanford Avenue looked like in the 1940s. They are just passing Jerry's Arcade and Dr. George Starke's office on the right. The buildings shown here are all gone. (Courtesy of Roberta Terry and the Sanford Museum.)

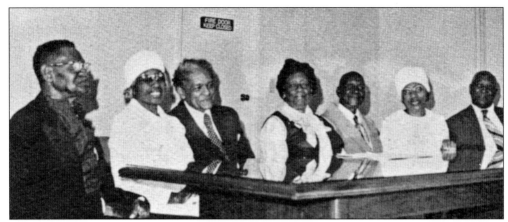

The Friendship and Union Benevolent Society was founded and organized by Abraham Robinson in 1888. It is the oldest local benevolent society in Seminole County. For years, the society owned burial property, which it sold to First Shiloh Missionary Baptist Church. The first six presidents were Terrell Johnson, Henry Williams, Lawrence Williams, Raymond Fields, and Sallye Fields Bentley. Pictured above are the 1978 officers making plans for the dedication of a building they erected on land they purchased at 621 Locust Avenue. Pictured are, from left to right, Elijah Ransom, Sallie Jackson, Dr. George Starke, Sallye F. Bentley, R. R. Fields, Edna Eaverly, and A. L. Brown. (Courtesy of Royce and Eddye Kay Walden.)

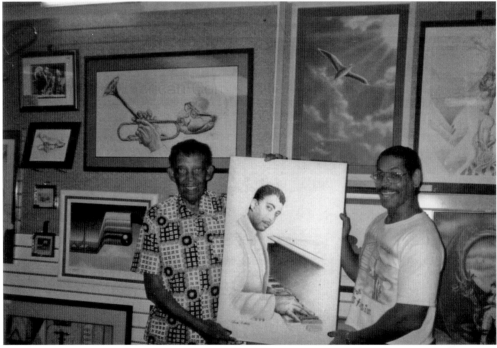

Carl Purdy (right) opened the first art gallery operated by an African American on First Street in what has traditionally been the white commercial area of Sanford. It was called Raphael's Realm. Carl is pictured with famed pianist the late Charlie Bateman. They are holding a portrait of Bateman done by Carl. Carl is the son of Dr. James Purdy, retired director of the Veterans Administration for the State of New Jersey, and Dr. Dorothy Purdy, a clinical psychologist. Carl is well known for his portraits of famous musicians. (Courtesy of James Purdy, Esq., and Dr. Dorothy Purdy.)

Dorothy Ringling, the wife of Dr. Julius Ringling, is pictured here with their newborn daughter Lorraine. (Courtesy of Lorraine Offer, Ph.D.)

Dr. Julius Ringling graduated from Howard Medical School in 1945. He practiced dentistry on Sanford Avenue in the building owned by Dr. George Starke. He is pictured here with his daughter Lorraine, who scribbled on the picture. Lorraine earned a doctorate in education and is married to Col. Ralph Offer. They have two daughters and several grandchildren. She is a retired elementary school principal. (Courtesy of Lorraine Offer, Ph.D.)

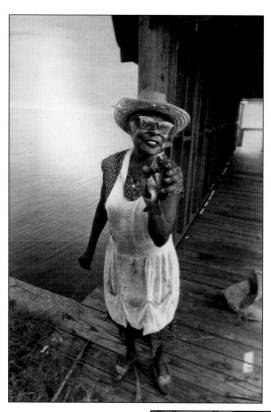

Photographer Angela Peterson was in Sanford looking for interesting people to photograph and found this little old lady, 85 years old at the time, fishing in the St. Johns River. She is Ruthie Mae Prince, better known as "Mama Sweet." She had just caught a fish. That was her dinner for the evening. Mama Sweet was a homemaker and lived at 815 Hickory Avenue in Georgetown. She was born in Lake City and moved to Sanford in 1920. She was a member of New Bethel Missionary Baptist Church. Her sister Lillie Patterson lives in Rochester, New York. Mama Sweet passed away in 1999 at the age of 92. (Courtesy of Angela Peterson.)

Alfreda Wallace (right), native of Goldsboro, is pictured outside of the Sanford Museum with author/poet Valada Flewellyn. The two ladies are leaving a 1995 meeting of the Sanford Historical Society. Alfreda is well known for having collected photographs and artifacts from residents of Goldsboro in order to write a book about the town. Due to personal issues, she was unable to write her book, but she served as spokesperson and advocate for preserving the town's history for many years. (Courtesy of the Sanford Herald Collection, Sanford Museum.)

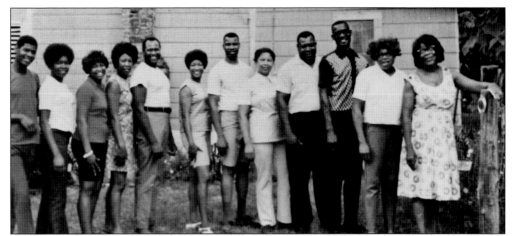

Cora Mullins Stallworth (1902–1976), wife of Rev. Samuel Stallworth Sr., is pictured on the right with her children, in chronological order beginning with the first born who is next to her: Mary, Samuel Jr., David, Ruth, Lemuel, Queen Esther, Luke, Martha, Electra, Rebecca, and Nathaniel. Most of the children graduated from Crooms Academy. The picture was taken in 1971 at the original family home in Oviedo. (Courtesy of Queen Esther Jones.)

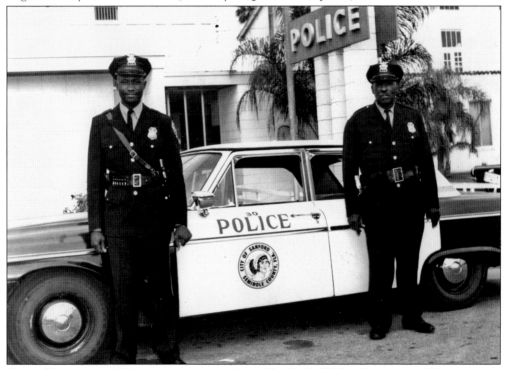

Pictured here are two African American members of the Sanford Police Department. The gentleman on the right is Willie Sutton, one of the first African Americans to join the force. Willie moved to Sanford from Georgia in 1926. He worked on farms before joining the police force in 1944. Willie worked in the Goldsboro area on the night shift. He attended the Florida Police Academy in Jacksonville in 1957. He is married and has five children. The other gentleman is unidentified. In March 2009, Cynthia Littles became Sanford's first female police sergeant and possibly the first female sergeant in Seminole County. (Courtesy of the Sanford Museum.)

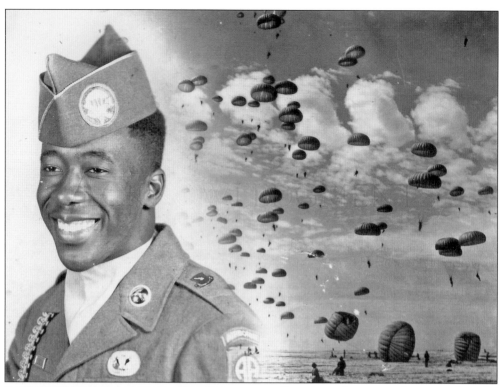

Rev. Amos Jones served as a member of the distinguished 82nd Airborne Division at Fort Bragg, North Carolina, for three years. (Courtesy of Queen Esther Jones.)

The bride in the photograph is Patty Swann, past president of the Sanford Historical Society. The African American lady at the wedding (on the right) is Nettie James, who worked for Patty's family. Patty shared the following story about Nettie: "Nettie lived at 611 Sanford Avenue and worked for Austin C. and Aline Williams, when I was a baby (1945–1950s). Later Nettie worked doing light ironing and light housework for my mother from the late 50s to the 70s. She had her own key to my parent's house and to our house. Nettie was invited to sit within the ribbon with the family at my wedding." Nettie is pictured on June 21, 1969, at the wedding of Patty Glenn Johnson to Richard Lee Swann at the First Presbyterian Church in Sanford. (Courtesy of Patty Swann.)

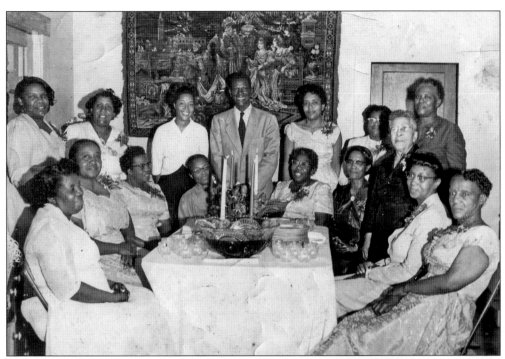

Midwife Marie Francis entertains a gathering of friends in the living room of her home. She is standing third from the right. (Courtesy of Daphne Francis Humphrey.)

Annie Clyde Walker is the sister of midwife Marie Francis. Annie came to Florida after traveling for many years with the Ringling Brothers Circus as a special assistant to Ringling. She stayed in many fine hotels and remembers that the china was broken after all of her meals. Annie helped her sister in her business as a midwife and later went to beauty school and operated a salon opposite the maternity ward at 621 Sixth Avenue. (Courtesy of Daphne Frances Humphrey.)

Young Marie Francis is playing the ukulele in her front yard. (Courtesy of Daphne Frances Humphrey.)

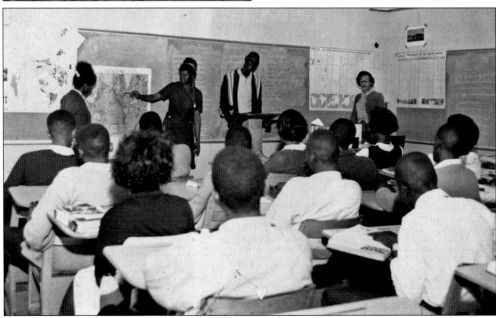

Daphne Francis Humphrey teaches a geography class at Crooms Academy. She is the daughter of midwife Marie Frances. (Courtesy of Daphne Francis Humphrey.)

Wilma King Coleman and her daughter Francis are pictured outside of the Allen Chapel African Methodist Episcopal Church in the 1980s. (Courtesy of Frances Coleman Oliver.)

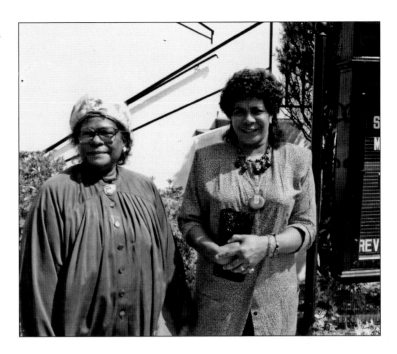

Beverly Brown (second row, third from the left), daughter of Willie and Julia Brown, was one of the first students to attend the all-white Southside Elementary School. Beverly, pictured in 1967, still remembers the uncomfortable feeling of being the only African American girl in her class. In 1968, the federal government mandated that to achieve integration children should be bused. (Courtesy of Beverly Brown.)

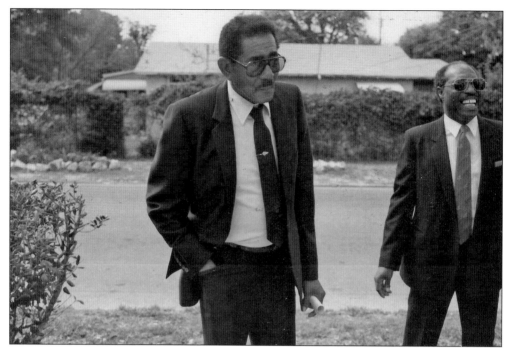

Levi Coleman and James Baskerville are pictured in the yard of the Coleman home on Bungalow Drive in the 1980s. Coleman was a contractor and built many of the homes on his street. Both gentlemen were members of St. Paul Missionary Baptist Church. The church holds an annual Father's Day breakfast in honor of Baskerville. (Courtesy of Francis Coleman Oliver.)

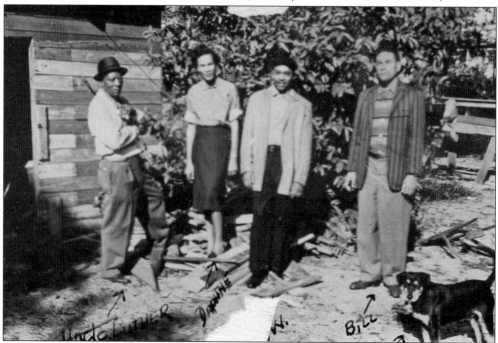

Daphne Francis (second from left) gathers with friends from the neighborhood in the yard of her home at 621 West Sixth Street. (Courtesy of Daphne Francis Humphrey.)

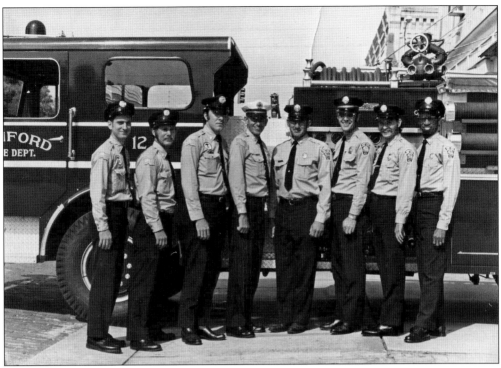

Dr. Hezekiah Ross is the son of George and Ella Ophelia Ross. He is the youngest of nine children. One of his early jobs was for the railroad company in the section gang. On February 14, 1969, he became the first black firefighter for the City of Sanford Fire Department. His early days at the fire department were difficult, but things improved over time. He serves as pastor of the West Sanford Free Will Holiness Church. He is the first ever chaplain for the City of Sanford Fire Department. From left to right are Steve Crews, unidentified, ? Cohen, Lt. Bill Lee, Willie Beren, Chuck Bose, Doug Luce, and Hezekiah Ross. (Courtesy of Lelia Ross.)

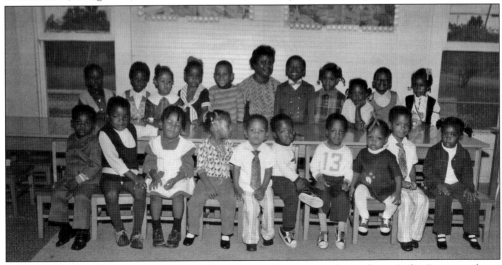

Lelia M. Ross and her class at Lawton Elementary School are shown here. Lelia Ross was born in Sanford in 1932 to Daniel Johnson and Emily Smith Benson. She graduated from Crooms Academy in 1949. She is married to Dr. Hezekiah Ross. (Courtesy of Lelia Ross.)

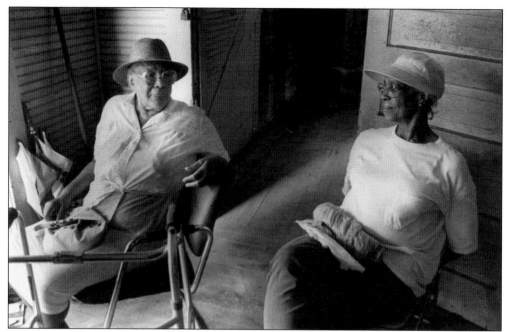

Here are local historians Altermese Bentley (left) and Ollie Williams. Altermese Bentley is the author of *Georgetown: The History of a Black Neighborhood*, the first book written about the community's history. Ollie Williams is the historian for the St. James African Episcopal Church. The two ladies are relaxing and sharing stories inside a classroom at historic Hopper Academy. (Courtesy of the Sanford Museum.)

Ollie Williams is pictured on the steps of the historic St. James African Methodist Episcopal Church. Ollie has been a member of the church all of her life. She serves as the church historian. Ollie is also active in the restoration of Hopper Academy. (Courtesy of Ollie Williams.)

Midwife Marie Jones Frances and her siblings, Luther Jones and Annie Clyde Jones, are dressed for a 1950s evening out. (Courtesy of Daphne Francis Humphries.)

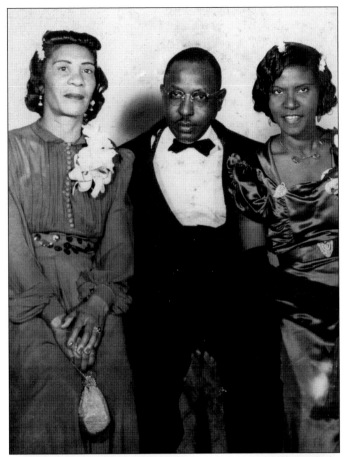

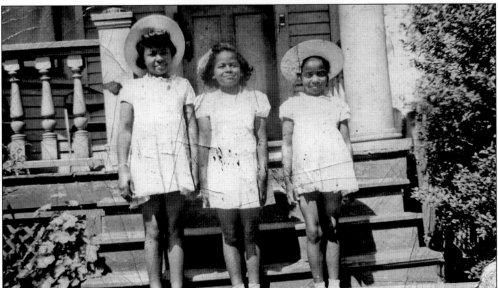

This photograph was a part of the Marie Francis estate photographs; the three little girls are unidentified. (Courtesy of Daphne Francis Humphries.)

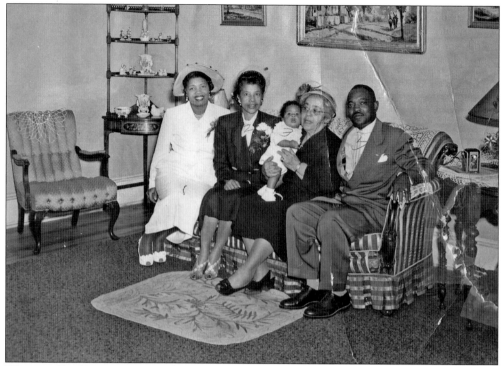

Educators Dr. Henry Francis and Juanita Green Gilmore are pictured in 1957 in their home at 616 Celery Avenue with their new baby boy, Ricardo. From left to right are Ms. Harris, Juanita Gilmore, Rosilie Lawson (grandmother, holding baby), and Dr. Henry F. Gilmore. (Courtesy of Juanita Green Gilmore.)

In 1957, Principal Roy Allen meets with two teachers. Juanita Green Gilmore is seated on the left and the other teacher is unidentified. (Courtesy of Juanita Green Gilmore.)

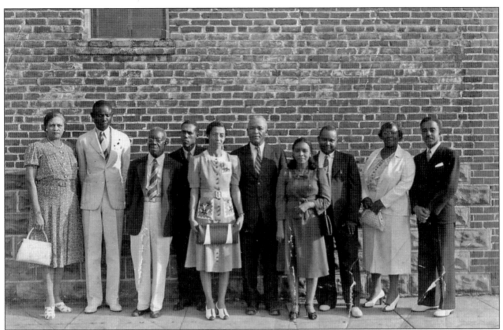

Sanford agents for the Afro American Life Insurance Company gather for a photograph. Abraham Lincoln Lewis of Jacksonville founded the company in 1901. It was the lone provider of life insurance for African Americans for decades. The company closed its doors in 1990. The first lady on the right is Katherine B. Holly, who was also a teacher at Crooms Academy. The company's office was located on Sanford Avenue in the building owned by Dr. George Starkes. (Courtesy of Willie "Pocket" Brown family.)

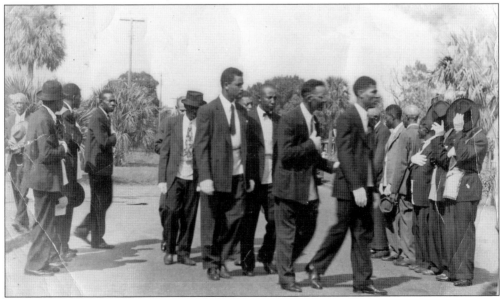

The Masons perform a traditional ceremony for a deceased member. The man in the center of the photograph is John Daniels, a Crooms Academy graduate. John was the first African American to be named to a city post. He was appointed to the Zoning and Planning Commission in the 1960s. (Courtesy of Willie "Pocket" Brown family.)

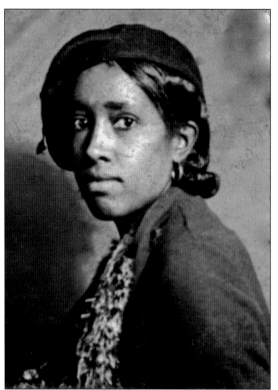

This is a photograph of Mrs. Irvin White, who lived on Cypress Avenue. (Courtesy of Ollie Williams.)

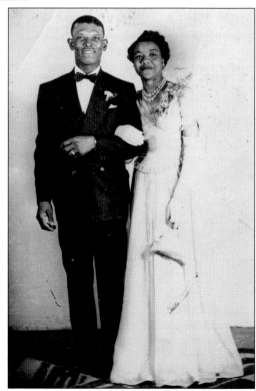

Laura G. Frazier was a teacher at Hopper Academy in the 1960s. Her escort is unidentified. (Courtesy of Willie "Pocket" Brown.)

Faye Oliver is at the piano, and her brother Loman plays the saxophone. Loman now is the pastor of the St. Paul Missionary Baptist Church. Faye is a physiologist. They are pictured in the living room of their home on Cypress Avenue. (Courtesy of Ollie Williams.)

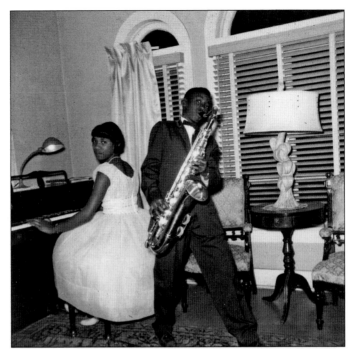

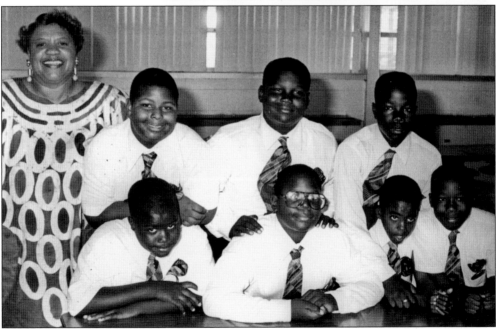

Patricia Merritt Whatley, a native of Sanford, is pictured with members of an after-school boys' club called Building on Your Self Image, which they did through the performing arts. Whatley directed along with Bernice Doe at Midway Elementary School. From left to right are (first row) Timothy Edwards, unidentified, Horace Cleveland, and Jazz Gipson; (second row) Leroy Thomas, Etrawn Hampton, and Marcus Jackson. Whatley is the founder of the Tajiri School of Performing Arts at 519 Palmetto Avenue. She taught special education at Midway Elementary and was Seminole County Teacher of the Year in 1991. (Courtesy of the Sanford Museum.)

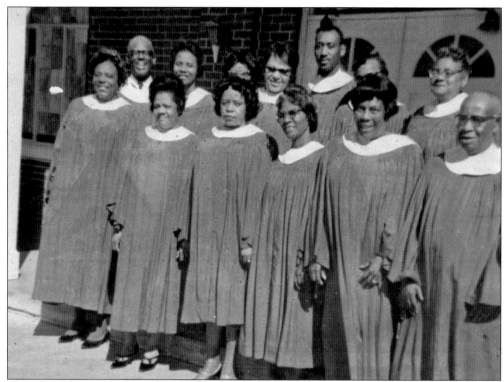

Members of the St. Paul Missionary Baptist Church choir gather for a photograph in front of the church in the 1960s. (Courtesy of Daphne Francis Humphrey.)

The St. Paul Missionary Baptist Church is pictured here in 1908. (Courtesy of the Sanford Museum.)

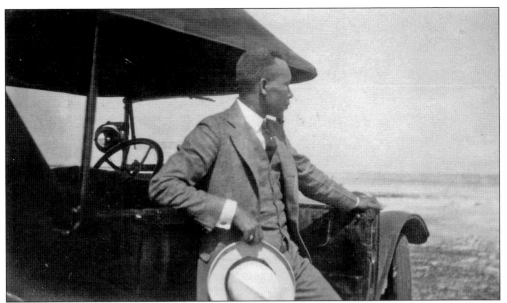

B. W. P. Allen gazes out on the St. Johns River. (Courtesy of Willie "Pocket" Brown family.)

This photograph of Alice P. Allen (left) and Anna L. Boyd (right) taken in the early 1900s was found in the Frank and Montez Harris estate. (Courtesy of Frank and Montez Harris Collection.)

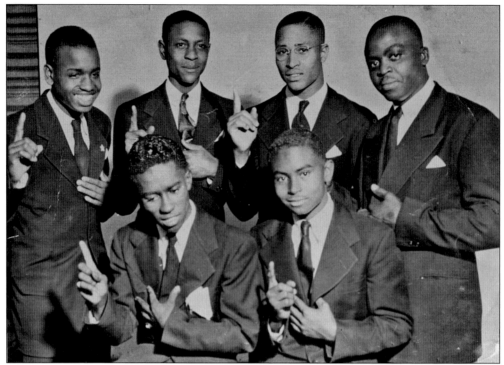

The Singing Kings of Joy originated in Sanford in 1944 with Cleve Gipson, Thomas Lawson, James Davis, Cleveland Debose, and others. They sang at churches, banquets, and other engagements. James Smith, Willie Baker, and Henry Debose became members in the 1960s. Floyd and Theo Stringer, Charlie Fareman, Harry Watson, John Henderson, and Johnny Golden sang with them in the 1970s. William and Isaac Glenn joined the group in the 1990s. For decades, the group has shared their faith through song. The current members are William Glenn, Isaac Glenn, James Smith, Fred Baker, Johnny Golden, David Brown, Chris Glen, and Joseph Darlins. Pocket Brown took this photograph in the 1960s. (Courtesy of Willie "Pocket" Brown family.)

Sanford's social elite is pictured here at the home of midwife Marie Francis (center). Identified in the 1960s photograph are Dorothy Ringling (far left), Ireta Martin (behind Marie Francis), Joseph and Wealthy Crooms (fifth and sixth from the left), and Juanita Gilmore (seated on the arm of the chair). (Courtesy of Daphne Frances Humphrey.)

Mary L. Jackson Fears and her husband, Joel V. Fears Sr., are pictured sharing information from her book titled *Civil War and Living History Reenacting about People of Color: How to Begin; What to Wear; Why Reenact.* The photograph was taken at a luncheon for authors given by the Chums at the Rio Pinar Country Club in Orlando. Mary L. Fears and author Valada Parker Flewellyn were the speakers for the luncheon. Mary, her husband, Joel Sr., and two sons, Joel Jr. and John, are all involved in Civil War reenacting. Mary shared another inspiring book titled *Julie's Journey*, a memoir written as a tribute to her daughter, Julie LaVera Anderson, born August 2, 1957, who passed away October 2, 1993. Julie's last words were: "I love Jesus." (Courtesy of Valada Parker Flewellyn.)

The Tajiri School of Performing Arts students gather for a jam session at the school, located at 519 Palmetto Avenue. Patricia Merritt Whatley founded the school in 1987. The classes in the early years were held in her home. The chairman of the Tajiri board was Thomas Flewellyn; John Simpson was school director and Toya Flewellyn, program director. Pictured in 2002 are Tina Flewellyn (left microphone), Jamaal Simpson (guitar), Tony Brown (trumpet), Allen English (drums), Howard Smith (instructor), Patrick Dennis, Brandon Richards (left keyboard), and Angelica English (right microphone). (Courtesy of EYESEEIMAGES.)

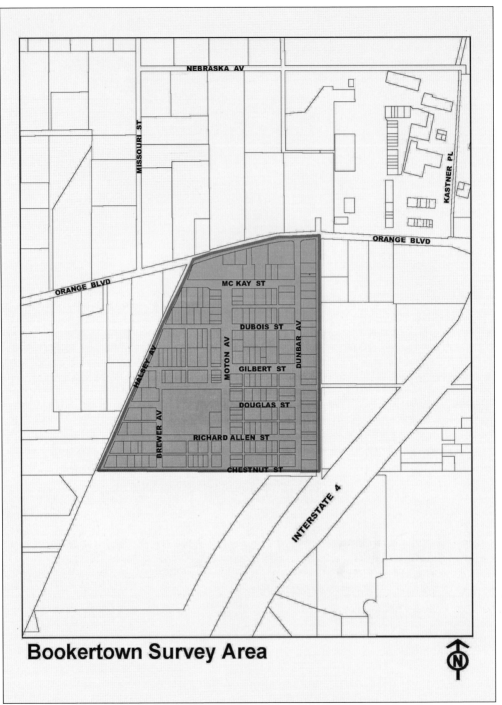

Bookertown Survey Area

This is a map of Bookertown; the larger community is Lake Monroe. In 1926, the Sanford Land Development Company bought a large tract of land from Michael M. Smith. This land was known as the "colored section." It was divided into lots and streets and became Bookertown, named for the famous educator Booker Taliaferro Washington. It is said his first name was chosen to make it clear that it was not George Washington who was being honored. (Courtesy of City of Sanford.)

Two

BOOKERTOWN

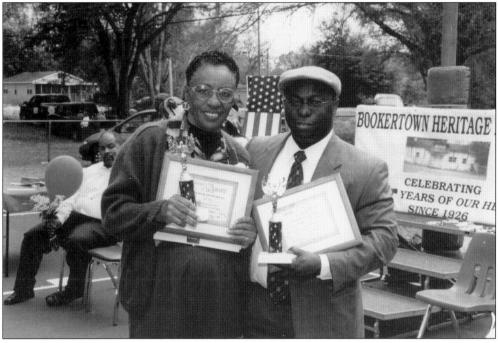

Bookertown is an African American neighborhood that grew into a full-fledged farming community built around the agricultural needs of Lake Monroe in Sanford. Bookertown residents were instrumental in building bridges around the river, clearing the rights-of-way, driving the spikes, and laying the steel rails that started South Florida's railroad history. They were employed by the railroads as firemen, porters, and cooks and in train and track maintenance jobs. In the early days, mostly farmers lived in Bookertown. The early railroad men lived near the Sanford shops in the black township of Goldsboro until about 1905, when a few section gang houses were built in the Monroe area. The farmers lived mostly in shanties or shacks built on the far edge of the farm. Bookertown is one of Florida's oldest surviving black farm worker communities. This photograph was taken February 26, 2005, at the Bookertown Heritage Festival founded by Charlie Morgan in 2004. Helen Ward and Rev. Curtis Coleman were rewarded for their community service. (Courtesy of Sanford Museum.) (Courtesy of EYESEEIMAGES.)

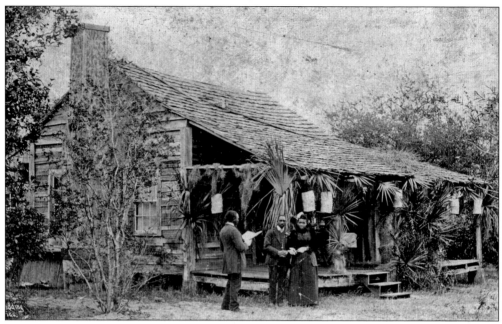

This African American wedding ceremony was held in front of what was a typical Florida home in the early 1900s. The porch is decorated with palmetto frond and Spanish moss. (Courtesy of the Sanford Museum.)

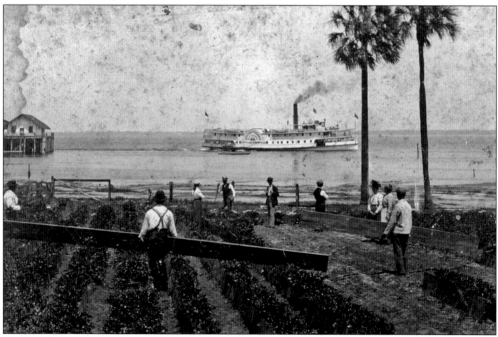

The gentlemen are boarding up the celery. Although there were a large number of tools invented for the handling of the celery crop, it was necessary to do much of the labor by hand. There was no satisfactory machinery devised for setting the plants, hoeing between the plants, and doing the finish work of banking, cutting and trimming, then bunching and packing it into crates. African Americans became skilled in all of these functions. (Courtesy of the Sanford Museum.)

From the Ditch Bank to Bookertown, published in 2005, was written by lifetime resident and local historian Charlie Morgan. Charlie began his writing career by coauthoring *Bookertown: A Journey to the Past* with Charlie Carlson, who grew up in the adjacent white community, Lake Monroe. Both history loving, Charles likes to point out that the only difference between them is that one is black and the other is white. Charlie Morgan is pictured on the cover of his book as a young boy, standing on the ditch bank. (Courtesy of Charlie Morgan.)

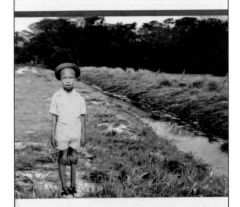

From the Ditch Bank to Bookertown

Charlie Morgan

The Sanford Historical Society, Inc.

The Rand Yard Ice House, pictured here in 2003, was a busy place because of all the produce that was being shipped. One could see the ice plant from Buchanan Quarters; the railroad cars were loaded with vegetables and fruit. The train track ran right past the building, making it easy to load. Vegetables and unused ice were discarded daily, and folks would come and glean; according to James Wilson and Charlie Morgan, "There was always plenty." The ice plant brought a new kind of employment. In 1928, there were 73 black workers on the ice plant's payroll. "Pushing ice" to fill refrigeration benders of railcars laden with vegetables was hard and dangerous, but it was steady and paid well. The ice plant also served as a storm shelter for families living in the rickety farm quarters. During a storm, the people would gather in the compressor room, which was very noisy but much warmer than the big ice storage area. (Courtesy of EYESEEIMAGES.)

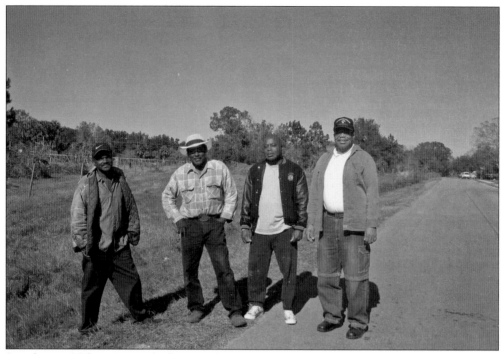

Standing on Halsey Avenue looking south are, from left to right, Frances Troutman, Robert Lee Scott, Buddy Fields, and Charlie Morgan. (Courtesy of EYESEEIMAGES.)

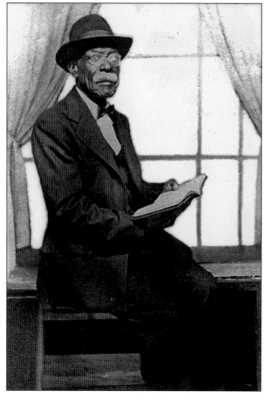

Rev. Isaac Sessions, pictured here in the 1940s, was a farm contractor who gathered laborers for planting and harvesting for the farmers. He was the second pastor of Providence Missionary Baptist Church. He lived in the largest house in Buchanan Quarters with his wife, Janie, and their children, Herbert, Isaac Jr., Martha, and David. When he was not preaching and caring for his church members, he was a crew leader for local farmers. He was known for driving around town in his 1939 Buick. (Courtesy of Charlie Morgan.)

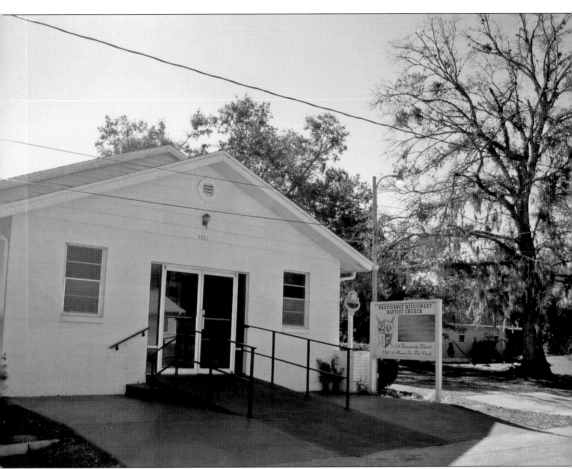

Providence Missionary Baptist Church is located at 4561 Douglas Street. It was established in 1917 and was the first African American church in Lake Monroe. The first minister was Rev. Henry Manning. He is responsible for the streets being named after black heroes and literary figures. (Courtesy of EYESEEIMAGES.)

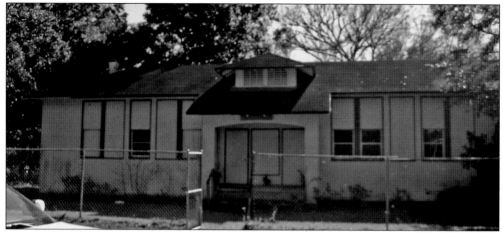

Bookertown School was built in 1919. It is listed in the public school records as the first official African American school in the area with Marsha Screven as the first teacher. In the 1940s, the school went to six grades and there were two teachers, Mrs. Bracey and Mrs. Hogan, who served as principal. The building of schools and churches became the first steps in forming the community. This school, though not recognized by the county school board, was the first in the area. The Bookertown School was the "private project" of D. H. C. Rabun, who was interested in keeping black workers near his farm because there was a shortage of labor. Students who graduated were able to finish high school at Crooms Academy after 1926. (Courtesy of Charlie Morgan.)

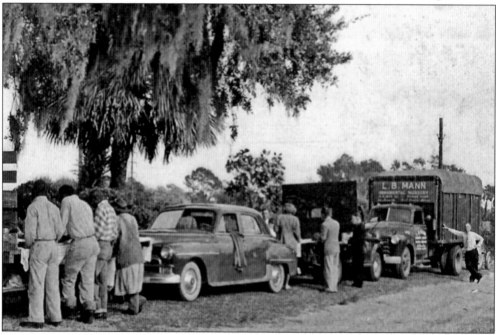

This is a picnic for the workers of L. B. Mann. In 1926, the Sanford Development Company agent L. B. Mann had the section of the Lake Monroe community surveyed into lots that became Bookertown. The first black pioneers during the 1880s worked for the railroad or as turpentine and sawmill laborers. Turpentine work was done on pine trees. The bark of the tree was shaved and resembled a cat's face, called "cat facing." A metal cup was nailed to the tree to catch the sap. (Courtesy of Mann family and Sanford Museum.)

The "Moses of Bookertown," Julius Mitchell was born into slavery in 1836 and died in 1953 at 117 years old. He was a farmer who raised chickens and later grew sugarcane. He built a two-story house on the corner of Orange Boulevard and Dunbar Avenue. (Courtesy of Charlie Morgan.)

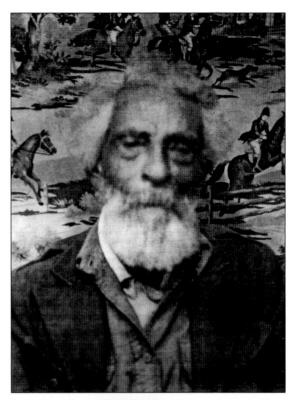

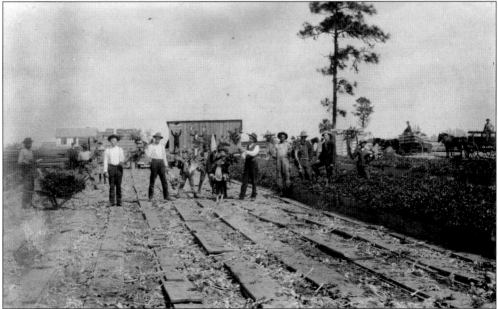

In the early 1900s, celery was cut by hand, partially stripped, packed into field crates, and hauled to the packinghouse. The first step in getting the celery to market is called "ditching the celery." These celery workers are about to begin that arduous task. Ditching and dicing was first done with shovels. In the 1930s, a rotary cultivator was developed to make the job easier. (Courtesy of the Sanford Museum.)

Virginia Wilson was photographed in Brown Studio in Georgetown. Virginia Wilson is the daughter of Rosa Mae Kaigler and Rev. Norris Wright Sr. of Bookertown. Virginia attended Bookertown Elementary and graduated from Crooms Academy in 1949. (Courtesy of James and Virginia Wilson.)

Virginia Wright is pictured in 1953 in the mirror prior to the wedding ceremony that took place in the living room of her family's home in Bookertown. (Courtesy of James and Virginia Wilson.)

Virginia and James "Chief" Wilson cut their wedding cake in 1953. Virginia is the daughter of Rosa Mae Kaigler and Rev. Norris Wright Sr. of Bookertown. Virginia attended Bookertown Elementary and graduated from Crooms Academy in 1949. James Wilson lived in Goldsboro. The couple were childhood sweethearts. (Courtesy of James and Virginia Wilson.)

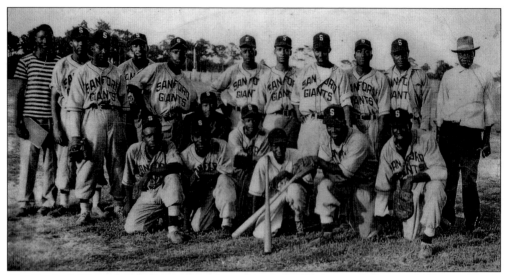

The Sanford Giants baseball team was formed in the 1950s by coach Roosevelt Harris. Coach Harris started the first Negro League in the area. He cleared out a large portion of his land and built a ballpark. Coach Harris owned a tavern called Hollywood Flats that was a popular hangout on Orange Boulevard, near Dunbar Avenue, through a gate that led to the ballpark and the tavern. Harris rented shanties around the tavern to black construction workers who came from Alabama, Mississippi, and other parts of the country to help build Interstate 4. Charlie Morgan and Dr. Calvin Collins both played for the Sanford Giants. (Courtesy of Charlie Morgan.)

Mr. and Mrs. Gaines are in the living room of their home on Richard Allen Street. The couple owned one of the mom-and-pop stores that sold soda pop and basic needs. Children walked to school from their small shanties on the Ditch Bank, which was an irrigation system that ran along Buchanan Quarters to Goldsboro past the Rand Ice Yard. (Courtesy Charlie Morgan.)

Evelyn Porter, the mother of Charlie Morgan, and Charlie's young daughter Pamela Morgan are pictured here in 1970. (Courtesy of Charlie Morgan.)

This is the Glen family. Mattie is standing on the left, Brice Glen Sr. is seated, Brice Glen Jr. is on his left, and baby Willie Mae Glenn is in her father's lap. This is in the early 1900s. (Courtesy of Charlie Morgan.)

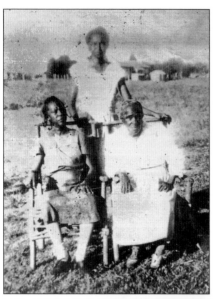

Alma Scott (standing), Pearl Blue (left), and Mary Mitchell relax in the yard after a hard working day. Alma and her husband, J. C. Scott, were among pioneers who settled in Bookertown. (Courtesy of Charlie Morgan.)

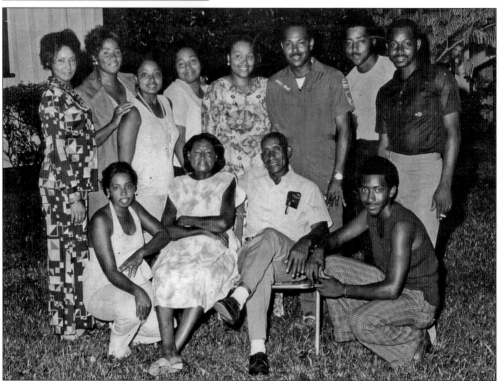

Alma and J. C. Scott and 10 of their 11 children are pictured here. J. C. Scott is his real name and not his initials. Many African American (men especially) used initials instead of their first name because they did not want white men calling them by their first name. J. C. was born in Eastman, Georgia, in 1922 and came to Florida with his father, Sidney Scott, to pick cotton at DeLeon Springs. He later worked in Seminole County cutting celery for Chase and Company. In 1935, he married Alma; the couple was together for 40 years. Alma passed away in 1984. (Courtesy of Charlie Morgan.)

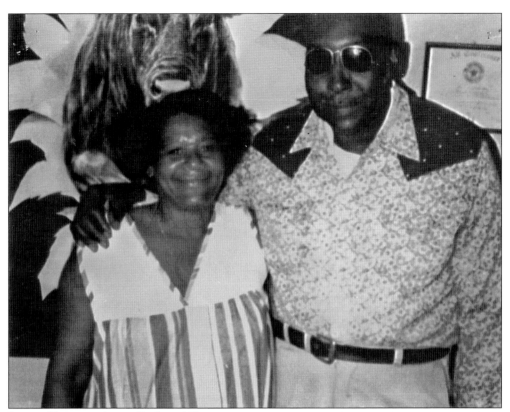

Pictured here are Annie Ruth and Ernest Campbell. (Courtesy of Charlie Morgan.)

Charlie Carlson grew up in the Lake Monroe area near Bookertown. He is the author of *Weird Florida* and many other books and magazine articles about Florida. He is coauthor with Charlie Morgan of the first book written about Bookertown. (Courtesy of Charlie Carlson.)

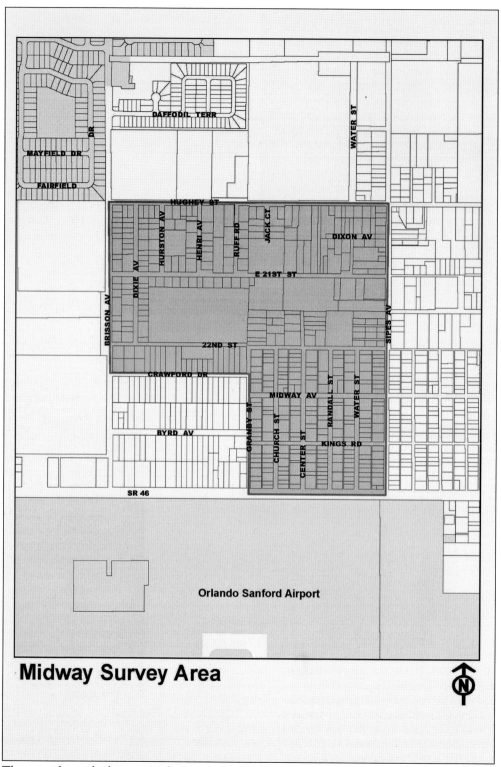

This map shows the historic Midway community. (Courtesy of City of Sanford.)

Three

MIDWAY/CANAAN CITY

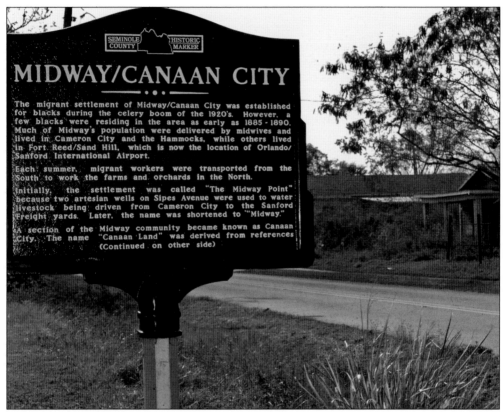

The migrant settlement of Midway/Canaan City was established for blacks during the celery boom of the 1920s; however, blacks had settled in the area as early as 1885. The settlement was first called "The Midway Point" because two artesian wells on Sipes Avenue were used to water livestock being driven from Cameron City to the Sanford Freight yards. The name was later shortened to "Midway." A section of the community became known as Canaan City, a term used by two itinerant preachers, Reverend Beatty and Father Owens, referencing "Canaan Land" in the Bible. Education began in the community in 1906 when Mrs. Millie Morgan, a graduate of Shaw University, started a private school in her home. Later a public school was established on Midway Avenue. Midway is located about 3 to 4 miles east of Sanford. Sipes Avenue is the center and heart of Midway, east of Sipes Avenue is "Midway Proper," and west of Sipes Avenue is referred to as "Back of Midway." This marker is located on Sipes Avenue. (Courtesy of Valada Parker Flewellyn.)

Vicki Brown Smith is Midway's storyteller; she spent several years collecting the stories of Midway's past and preserved it for future generations. Vicki was born in Midway, and like most of the children in the area, she was delivered Emma Clair. She is the only daughter of George and Lubertha Randall-Brown. Vicki grew up with five of her six brothers. She attended Midway Junior High School and graduated from Crooms Academy. She is a retired schoolteacher and mother of five children. She worked part-time as secretary in the Seminole County judge's office as a licensed insurance underwriter. She and her late husband, John, owned and operated two convenience stores and a secretarial service. She is a member of Allen Chapel African Methodist Church, the Kappa Sigma Omega Chapter of Alpha Kappa Alpha, Inc., and several other organizations. She wrote the first documented history of the Midway community (pictured below). (Courtesy of EYESEEIMAGES.)

Midway—the Midpoint. My Precious Memories of Time Gone By . . . The Reminiscences of a Child Growing Up in the Little Migrant Community of Midway-Canaan City was written by Vicki Brown Smith in 2002. (Courtesy of Vicki Brown Smith.)

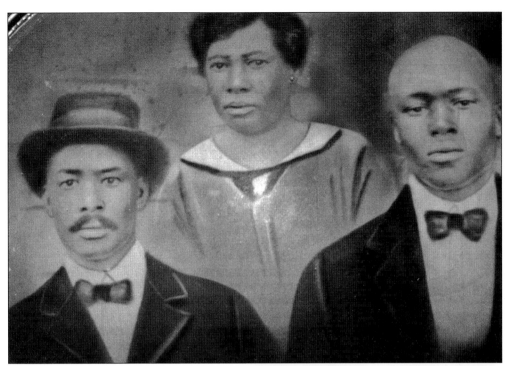

Hallie Taylor Redley is the grandmother of Albert Saunders Jr. She moved to Midway from Madison, Florida, with her husband, Authur Redley, in 1917. Hallie is pictured here with her two brothers, Bud (left) and Simon (right). Their parents were Chaney and Edward Redley. (Courtesy of Willie Albert Saunders.)

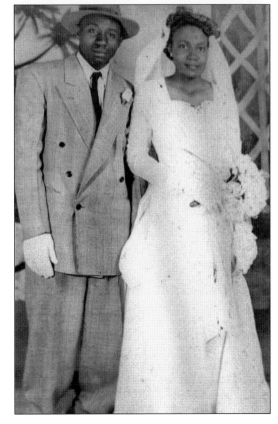

Albert Saunders Jr. and Ida Mae Walker-Saunders were married at the St. Matthews Missionary Baptist Church in Midway. Albert worked for the State of Florida at the Experiment Station run by the University of Central Florida Agriculture Department. He later worked for Pan American Airways in the transportation department. Albert transported the first astronauts to and from the launch pad on shuttle buses. He commuted daily from Midway to Cape Canaveral for 25 years. Albert was killed by a drunk driver. Five children were born to this blessed union: Willie Albert, Helen, Tommy, Janet, and Valerie. (Courtesy of Willie Albert Saunders.)

Four of Ida and Albert Saunders' five children are pictured here at Silver Springs, a popular recreation area in the 1960s. From left to right, they are Willie Albert, Helen, Tommy, and Janet. (Courtesy of Willie Albert Saunders.)

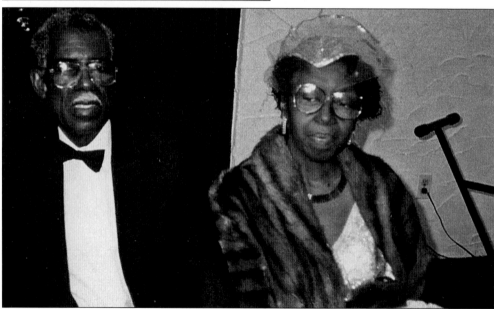

Joseph Jackson Sr. (1918–2003) and his wife, Bobbie, enjoy an elegant evening out. In the early 1960s, Joseph Jackson, a factory worker and a shade-tree mechanic, and a group of 10 men organized the Midway-Canaan Volunteer Fire Department. He served as the first black fire chief in Seminole County from 1962 to 1972. Charlie Lester succeeded him. In 1974, Seminole County took over fire services. On any day or night, the screaming burnt-red siren atop a telegram pole next to the gas pumps at Martin's Sundries would stop residents in their tracks and call them to service. A house somewhere is on fire. His fund-raising efforts led to the purchase of two fire trucks. (Courtesy of Cynthia Kendrick Walden.)

Sam McKinney was born into slavery in the mid-1800s. He married Mary McKinney; to this union, one son was born, Prince McKinney Sr. Sam was 104 years old when he died. (Courtesy of Sandra McKinney Duval.)

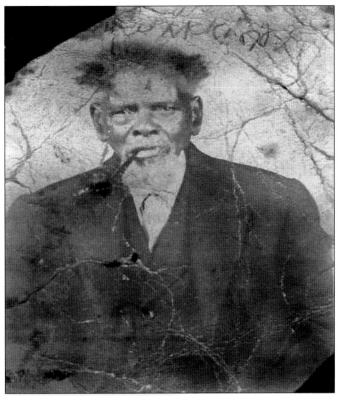

Dr. Calvin Collins Jr., a physician, grew up in Midway and graduated from Crooms Academy. He and his wife, Lottie, founded the *Orlando Times* newspaper. The paper has served the African American community in Central Florida since 1976. (Courtesy of Kevin Collins, the *Orlando Times*.)

The Prince McKinney family and descendants of Samuel McKinney are pictured at the Bethune Beach on a Sunday afternoon after church. (Courtesy of Sandra McKinney Duval.)

The Prince McKinney family members gather for a photograph after a 1991 Christmas dinner at the lovely home of Prince McKinney III in Midway. (Courtesy of Sandra McKinney Duval.)

Jesse Lee "Man" Kendrick is pictured riding his prized tractor. The Kendricks raised 10 children and 4 grandchildren, along with 2 of his sister's children. Jesse worked for A. Duda and Sons as a foreman and farmed his own property in Canaan. While working at A. Duda and Sons, Jesse invented a machine for the canals. As he explained it, he was just trying to make his job easier. Jesse never received a patent or credit for the device, which was used on the farm until recently. After retiring, he started a cab business that he calls the "Special Cab." (Courtesy of Cynthia Kendrick Walden.)

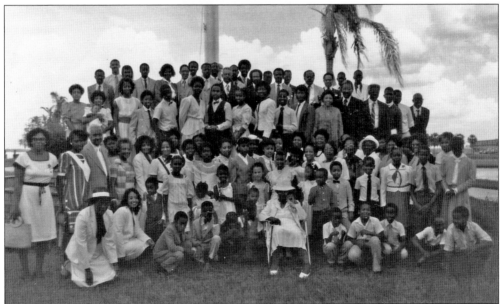

Mary Lou Singletary at age 100 is surrounded by six generations. The photograph was taken at the Sanford riverfront during the Kendrick family reunion. Mary was born in 1887 to William and Leah Kendrick in Sumter County, Georgia. She is one of their 16 children. She was a mystic who had cures for illness to which doctors now are giving some validity. Cynthia tells the story of having whooping cough, and "grandma had my brothers go to the ditch and get a bull frog, she killed, skinned and cooked the frog's legs and made me eat it and my whooping cough was cured." (Courtesy of Cynthia Kendrick Walden.)

This is New Bethel African American Methodist Episcopal Church; Bishop McKinley Young, Elder Leroy Kennon, and Pastor Odell Watson officiate. Members built the first New Bethel African Methodist Episcopal Church in Canaan City in 1910. The old church had a bell tower that bell ringers used to convey messages to the residents. The original organizers were Rev. Sebron Waldon, Tom Taylor, Bonnie Garvin, John Jenkins, and their families. (Courtesy of EYESEEIMAGES.)

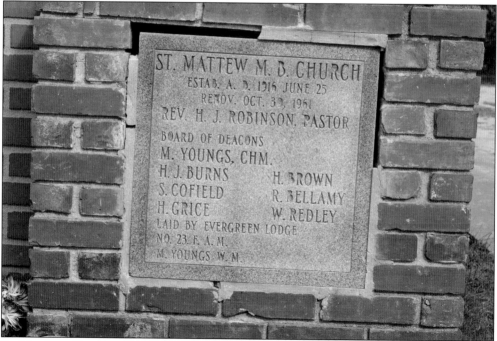

St. Matthew Church was established on June 25, 1916. St. Matthew is the largest church in Midway/Canaan. For many years, it served as a school. The current pastor is Leonard Wilson. Leonard is the son of Ruby Wilson of the Good Samaritan Home in Goldsboro. (Courtesy of EYESEEIMAGES.)

Moses Barfield and his wife, Willie Mae (pictured below), migrated to Midway from Madison around 1935. Moses enjoys sitting and looking out at the property enjoying the sunshine. (Courtesy of EYESEEIMAGES.)

Willie Mae Barfield was born in Madison and lived in Sanford for 62 years. She was a foster grandparent for Sanford Childhood Development and a member of St. Matthews Baptist Missionary Church. She passed away in March 2009 at the age of 84. She is survived by her husband, Moses, and daughters Beatrice, Betty, and Virginia, 16 grandchildren, 29 great-grandchildren, and 11 great-great-grandchildren. (Courtesy of EYESEEIMAGES.)

Freddie "Bear Grease" Williams (right) and retired friends meet regularly under a tent in his yard to play dominoes. He worked in construction and was the foreman on the building of Bram Towers and other buildings in Sanford. He retired after directing the Boys and Girls Club in Goldsboro. He now lives what he calls "the good life." (Courtesy of EYESEEIMAGES.)

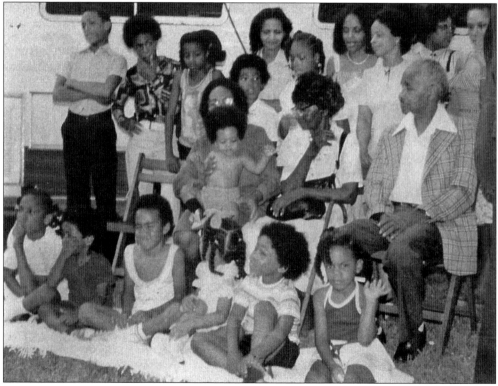

The children in the Kendrick family gather around their grandparents. (Courtesy of Sandra McKinney Duval.)

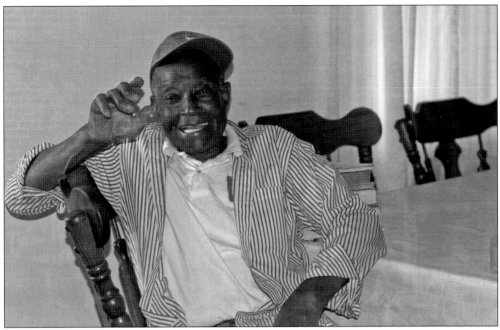

Richard Howell and his wife, Mary, live on Greenway Avenue. (Courtesy of EYESEEIMAGES.)

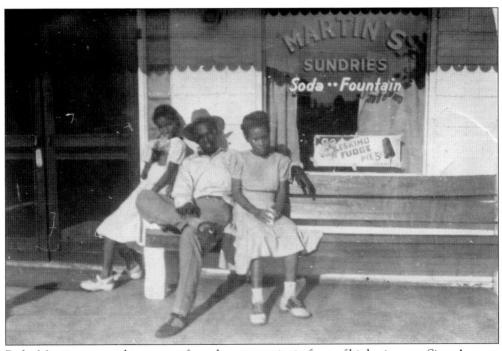

Rufus Martin poses with two teens from the community in front of his business on Sipes Avenue, Martin's Sundries (called "The Soda Fountains"). The shop was a community meeting site and a hangout for Midways teens. (Courtesy of Cynthia Kendrick Walden.)

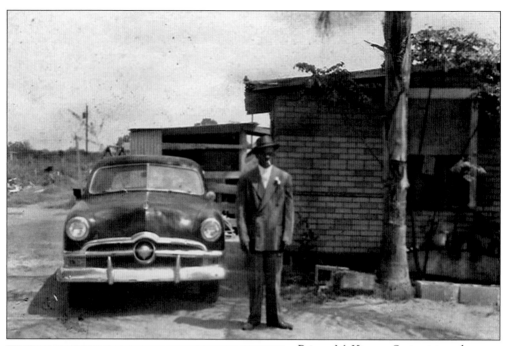

Prince McKinney Sr. is pictured at home with his 1949 Ford. Prince is the son of Samuel McKinney. (Courtesy of Sandra McKinney Duval.)

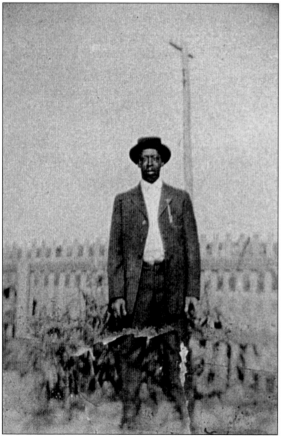

Dr. Joe Kendrick is pictured here in the yard of the Kendrick family home next door to Albert and Ida Saunders in the 1970s. Joe is the son of Jesse Lee and Mary Lou Kendrick. He is a practicing veterinarian living in Knoxville, Tennessee. Dr. Kendrick, his wife, and two sons are all veterinarians. (Courtesy of Sandra Mckinney Duval.)

Kenneth and Vanessa King are pictured with their grandson. They both graduated from Crooms Academy. Kenneth is from Goldsboro, and Vanessa is from Midway. They now live in Atlanta. This was a picture taken on one of their many visits back home to Midway. Vanessa's mother, Ida Mae, prepared one of the "coons" out of her freezer to celebrate their visit. Kenneth King is the son of Deacon Willie King and Berneice Vann, members of the Zion Hope Missionary Baptist Church in Georgetown. (Courtesy of EYESEEIMAGES.)

In 2006, Willie and Berneice Vann King were honored by the Zion Hope Missionary Baptist Church for their years of dedicated service to the church. The Kings have five children: Lee, Joyce, Shiela, Willie Jr., and Kenneth.

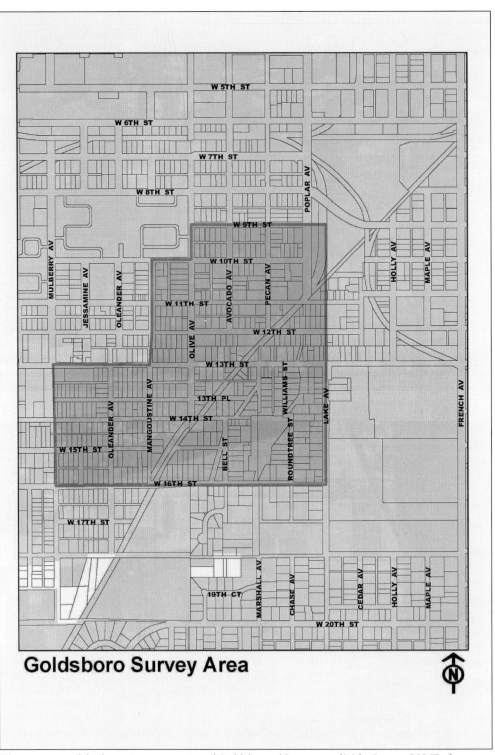

Goldsboro Survey Area

This is a map of the historic community of Goldsboro. (Courtesy of Mike Jones, GIS Technician, City of Sanford.)

Four

GOLDSBORO

The African American community of Goldsboro was incorporated in 1891 and functioned as a bustling town with its own government and services. It was annexed into Sanford in 1911 because of the fear that it would impede the growth of Sanford. Residents put several pleas in the local newspaper to be left alone and to remain a town. In spite of their pleas, state legislator Forrest Lake led the charge to revoke the town's charter. Truck farming engaged a large number of laborers. Many worked for large companies like Chase and Company, Hutchinson, Standard Growers, American Fruit Growers, L. A. Brumley, and others. One of the largest washhouses in the state was in Goldsboro. It produced a railroad carload of celery every 20 minutes, with women doing the packing. Workers at the ice plant turned out 45 tons of ice per day. A labor shortage in the 1940s prompted the City of Sanford to build the migrant labor tent city in Sanford. The lack of housing caused the schools to operate in shifts. In the 1950s, federal funds supported the building of housing projects, like Castle Brewer and William Clark Courts.

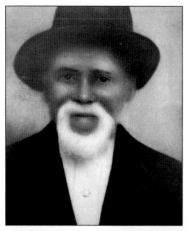

This *c.* 1900s image features William Walden who was among the first African Americans to purchase land and settle in the area that would later (in 1891) become the incorporated town of Goldsboro. Goldsboro was the second black town in Florida to incorporate; Eatonville was the first. Walden's daughter Laura married the town's founder, William Clark. His son Albert was the third mayor of Goldsboro. (Courtesy of Royce and Eddye Kay Walden.)

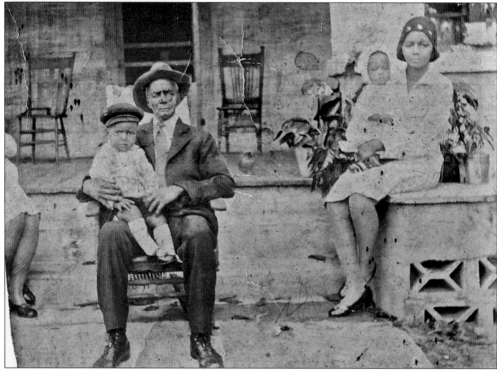

William Clark is responsible for the incorporation of Goldsboro in 1891. He is pictured here with his grandson Hubert Ford. Clark sold lots to homeowners and brought the citizens together to petition for incorporation. It is quite likely Clark was familiar with Eatonville's incorporation (1887) and decided incorporation would be best for Goldsboro as well. In 1891, Clark, along with his father-in-law, William Walden, and other members of the community, drew up articles of incorporation and developed a town seal. Goldsboro remained an incorporated town until 1911, when the City of Sanford, led by Forest Lake, former mayor turned state legislator, decided that the town of Goldsboro interfered with Sanford's growth and should be dissolved into Sanford. The townspeople resisted; they wrote letters to the state government and local newspaper pleading to be left alone. These pleas fell on deaf ears and in April 1911, the Goldsboro and Sanford charters were dissolved and a new charter was drawn up that incorporated them into one town, Sanford, with Goldsboro as a community. (Courtesy of Hubert and Donna Ford.)

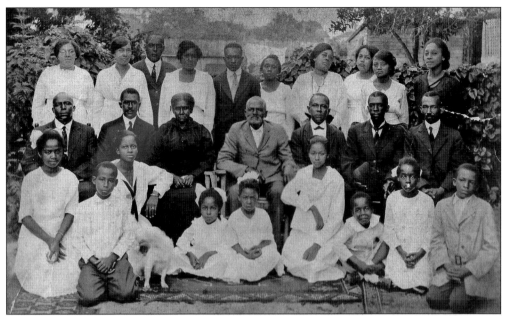

Moses and Daphne Crooms were enslaved on a plantation in Tallahassee before settling in Central Florida. They are seated at center surrounded by their children and grandchildren in this 1918 photograph. Joseph N. Crooms, principal to Hopper Academy and founder of Crooms Academy where he was also the principal, is their son. He is pictured on the back row next to his wife, Wealthy. Their daughter Nathalie is seated in the first row. (Courtesy of Sally Crooms Richmond.)

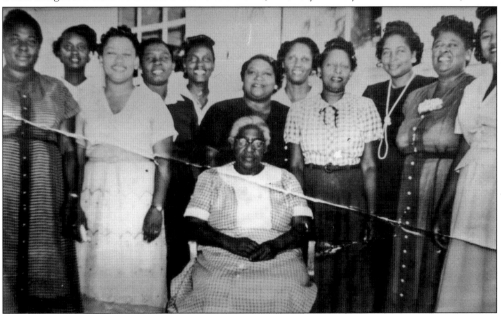

The Goldsboro Elementary 1952–1953 faculty is shown in front of the school. The school was fondly called the "Little Red School House." Principal JoAnna Moore is seated in the center. From left to right are (standing) Ella Moore, ? Green, Rebecca Hankerson (Henderson), Francis Pike, Thelma Franklin, Floretta Smith, Vivian Lamb, Sally Fields, Thelma Debose Hall, and ? Patterson. (Courtesy of Georgetown Collection, Student Museum.)

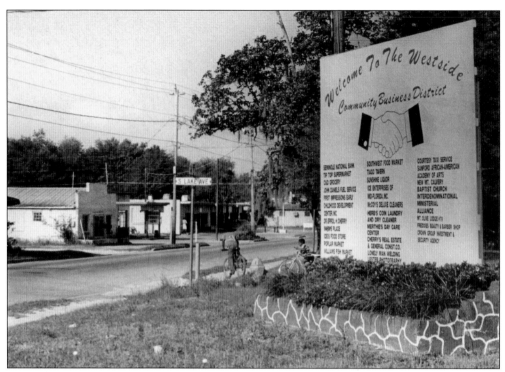

The entry to Goldsboro in 1994 had this large wall with a list of the stores that line Thirteenth Street. (Courtesy of the Sanford Herald Collection, Sanford Museum.)

The Star Theatre was where black people in the area went to the movies. Black entertainers who came to town performed on the stage. The Ritz Theater, downtown, required blacks to enter from the side door and sit upstairs. When asked about it, author Vicki Brown Smith said, "We didn't mind it too much because they were the best seats. Some of the kids would throw things down there. No, we didn't mind it at all; after all we had our own theater." (Courtesy of EYESEEIMAGES.)

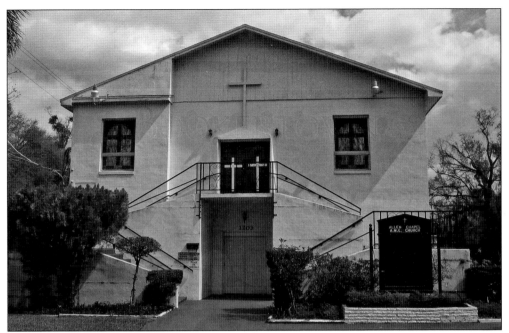

The Allen Chapel African Methodist Episcopal Church was organized in 1893 when 18 members of St. James AME, the mother church, decided they needed a place to worship in their own neighborhood. Rev. Frank Hall, along with other members of St. James, led the effort, and in 1894, a church was built on the corner of Lake Avenue (then Clark Avenue) and Thirteenth Street. It was completed and dedicated under the leadership of Rev. T. J. Williams on a lot purchased from the town's founder, William Clark. Today Allen Chapel is located at 1203 Olive Avenue. (Courtesy of EYESEEIMAGES.)

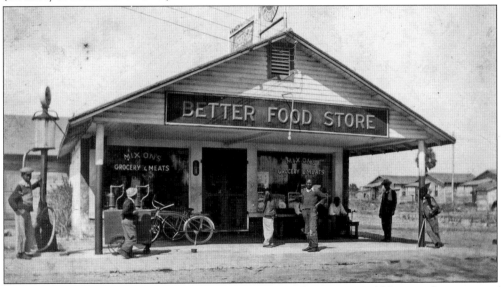

Mixon Better Food Store is located at 1700 West Thirteenth Street in Goldsboro, with proprietors William and Mazie Mixon. The store was a popular stop for workers before catching the truck to the fields to pick fruit or vegetables. This is where they purchased drinks and snacks. The image is dated 1947. (Courtesy of the Sanford Museum.)

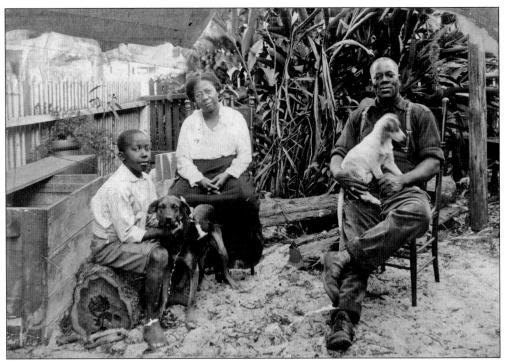

The Boykin family is shown here. William Boykin was the fourth and last postmaster for the town of Goldsboro. His wife, Rosa, held the title of postmistress. They served from 1896 to April 15, 1913, when mail to Goldsboro was discontinued. Ten days later, Seminole County was created out of part of the northern portion of Orange County. The other postmasters were John W. Small (1892–1896), Henry L. Duhart (1896–1898), and George W. Benton, who served for 16 days in 1898. (Courtesy of the Sanford Museum.)

Irma Copper (left) and Neda Boykin (right) are members of New Mount Calvary Missionary Baptist church. They are pictured here in 2006 at the 88th anniversary of the church. (Courtesy of EYESEEIMAGES.)

Marva Hawkins leaves the 2006 "Historic Town Hall Meeting" at the New Mount Calvary Missionary Baptist Church, held for the documentary *Goldsboro: An American Story*. The film was a collaborative effort between the Sanford Historical Society, the University of Central Florida, EYESEEIMAGES, and benefactor Donald Jones. Marva is featured in the film giving the history of the businesses that once lined Thirteenth Street. Marva has lived in Goldsboro all of her life. She is "the voice" of the community and for decades has written a column in the *Sanford Herald*. (Courtesy of EYESEEIMAGES.)

The Marching Men of New Mount Calvary are the male ushers at New Mount Calvary Missionary Baptist Church in Goldsboro. Frank "Sonny" Copper is in the center. Members of the group are well known for their fancy steps and colorful suits. They are serving at the 88th anniversary of the church in 2006. (Courtesy of EYESEEIMAGES.)

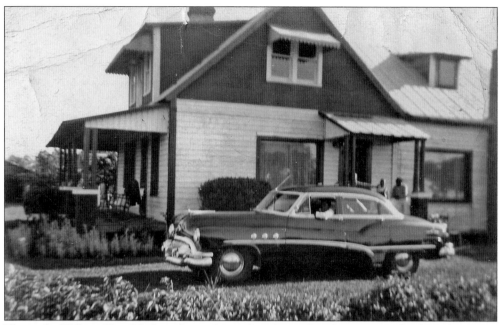

This is the William "Page" Jackson home, located on the road to the cemetery that bears his name. Jackson was a farmer and was usually working in the field when funeral processions passed. He would wave at the families as they passed. His grandson, Royce Walden, grew up in the house and remembers playing in the yard. He recalls sneaking up and peeking in on the teenagers who parked in the cemetery at night for privacy. The home was burned down in the 1950s, and a new home was built. The home is still owned by the family. (Courtesy of Royce and Eddye Kay Walden.)

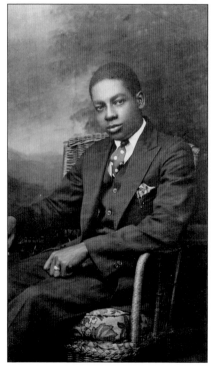

James Walden Sr. is the son of Albert Walden, former mayor of Goldsboro in the1900s. He married Vivian Jackson, the daughter of William "Page" Jackson. James raised his family on the Jackson property near the cemetery named for his father-in-law. (Courtesy of Royce and Eddye Kay Walden)

Phoebe and Elizabeth Jackson are in the yard of the Jackson home on Twenty-fifth Street. The property had many fruit trees. William "Page" Jackson farmed the land and sold his produce at the marketplace in town. (Courtesy of Royce and Eddye Kay Walden.)

This is Royce Walden, son of James and Vivian Walden, sitting in a rocking chair on the porch of the family home on Twenty-fifth Street. (Courtesy of Royce and Eddye Kay Walden.)

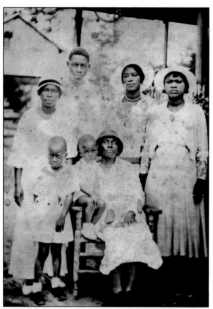

Vivian Jackson is pictured with her children and grandchildren. The little boy standing next to her is Royce Walden. (Courtesy of Royce and Eddye Kay Walden.)

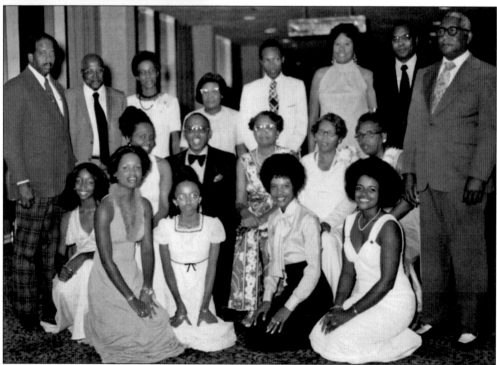

In the 1970s, the Thomas and Gussie Wilson family celebrated the retirement of Olive Wilson Johnson, who taught in the Seminole County Public Schools for over 20 years. From left to right are (first row) Lanedra Carrol, Jamia W. Wilson, Jamiel Nina Wilson, Vicki Killings, and Chris Wilson; (second row) Virginia Wilson, James Wilson, Olive Wilson Johnson, Carrie Wilson Irvin, and Eunice I. Wilson; (third row) Dan Killings, Timothy Wilson, Thelma Nathan Mike, Annie May Stokes, Thomas Wilson III, Mildred Wilson, Thomas Wilson II, and Aaron Wilson. (Courtesy of James and Virginia Wilson.)

Featured in this c. 1950s image are Royce and Eddye Kay Walden. They met at Florida Agricultural and Mechanical College, and they have been married over 50 years. Royce is a Goldsboro native, and Eddye Kay is from Ocala. They have one daughter, Donna Kay. The Waldens are very supportive of the migrant community in the area. They offer yearly scholarships to children of migrant workers. Royce was the first African American to be appointed assistant to the superintendent for the Orange County Public Schools (1974) and the first to serve as president of the United Way of Central Florida. He has served on numerous boards and was appointed to the board of directors of Florida Bar Association for two terms. (Courtesy of Royce and Eddye Kay Walden.)

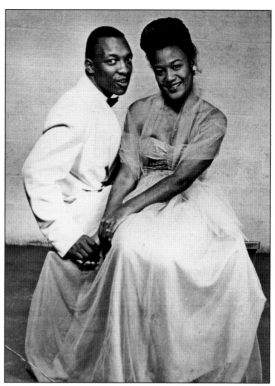

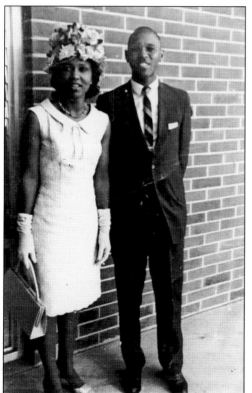

James and Virginia Wilson both graduated from Crooms Academy. James was from Goldsboro and Virginia from Bookertown. James played in the band at Crooms under the direction of George H. Hill. He then went to Florida Agricultural and Mechanical University, played under the direction of Dr. William P. Foster, and received a degree in music. A Jones High School legend, he was director of the Jones High School band for his entire career from 1950 to 1990. The students refer to him fondly as "Chief"; however, his friends and family in Goldsboro call him "Buttons." The music building on the Jones High School campus is named in his honor. James has served on the board of the Central Florida Credit Union for over 36 years. Like their friends the Waldens, they have also been married more than 50 years. James and Virginia are both retired educators. (Courtesy of James and Virginia Wilson.)

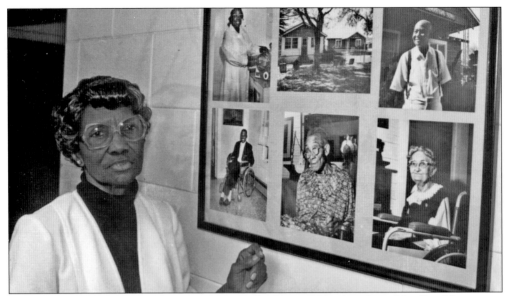

This is Thelma Mike standing next to a picture of her parents, the founders of the Good Samaritan Home in Goldsboro, in 1948. The home (top center) served as a refuge for seniors and anyone in need of help. When asked about her parentage, Thelma Mike shares, "Not believing in step and half, God blessed me with two sets of parents, Timothy and Ruby Wilson, and Nellie Mae and James Miller." After the death of her parents, Thelma and her daughter Victoria Murphy took over the management of the home. Thelma has received many awards and accolades for her many years of service. (Courtesy of the Sanford Herald Collection, Sanford Museum.)

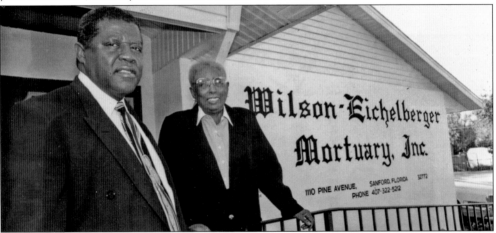

Eunice Wilson was born in 1917 and is one of Gussie and Thomas Wilson's six children. Eunice is the owner and operator of the Wilson Eichelberger Mortuary, Inc. The Wilson family is one of the early families who settled in Goldsboro. Eunice loves sports and participated in basketball, tennis, and volleyball. She always knew she wanted to be an undertaker, as they were called then; she would gather all the dead birds, cats, or any other animals, put them in shoeboxes, and proceed to have a funeral. Her brother was the preacher, and her other friends played the role of the family; she, of course, was the undertaker. The gentleman in the photograph is Bernard Mitchell, the manager and director of the Wilson Eichelberger Mortuary, Inc. Bernard and Eunice have both won many awards in their field. (Courtesy of the Sanford Herald Collection, Sanford Museum.)

Herbert Cherry was born in Sanford in 1920 to Lonnie and Lillie Cherry. He graduated from Crooms Academy in 1941. He married Mattye Lee Williams while at Crooms Academy. He continued his education after Crooms at Tyler Barber College in Tyler, Texas. He returned home and opened his own shop at 1219 West Thirteenth Street. He and Mattye Lee built a home on Fifteenth Street, and in 1960, he built Cherry Plaza. Herbert Cherry organized the first Parent Teacher Association at Crooms. He is a member of St. Johns Missionary Baptist Church. This picture was taken in 2006. (Courtesy of EYESEEIMAGES.)

Herbert Cherry owns Cherry Plaza on Thirteenth Street. The plaza has three storefronts and four offices in the back. He tells the story of how he saw a Cherry Plaza in Orlando and vowed he would own one. Cherry was a realtor for many years and owns other property in Sanford. He also drove a school bus that transported children to Crooms Academy. (Courtesy of EYESEEIMAGES.)

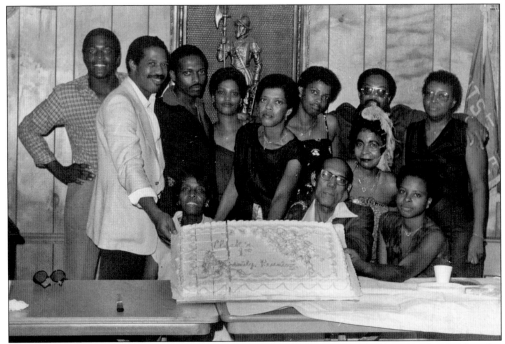

Mannie Clark Sr. celebrates his birthday with family. Mannie is the father of eight children he raised alone in a house near Thirteenth Street in Goldsboro. From left to right are Dennis William (stepbrother), Mannie Clark Jr., Furman Clark, Carolyn Clark, Claudette Clark, Cynthia Clark, Tiny Foster, Anthony Clark (behind Tiny), Betty Renfro (stepsister), Carolyn Clark (seated), and Mannie Clark Sr. (Courtesy of Claudette Clark Hutchinson.)

Claudette Clark Hutchinson is one of Mannie Clark's eight children. She owned and operated a beauty shop on Thirteenth Street in Goldsboro. Claudette was one of the residents featured in the documentary *Goldsboro: An American Story*. (Courtesy of Claudette Clark Hutchinson.)

Mannie "Boy" Clark Jr. is the son of Goldsboro pioneer Mannie Clark Sr. Mannie Jr. moved to New York City and worked in security at the World Trade Center. In his effort to help others, he was tragically killed on September 11, 2001. (Courtesy of Claudette Clark Hutchinson.)

This is a picture of the famous graffiti artist A-One (Anthony Clark) at around age three. He is the son of Janette Gordon Clark and the grandson of Mannie Clark Sr. A-One grew up in New York, but his roots are in Sanford, Florida. He died in his early thirties but had already made a name for himself in the art world. He was a friend of artist Jean-Michel Basquiat and felt that Basquiat taught him how to become involved with galleries and learn the rules of the art world. He became one of the youngest artists ever to participate in the Venetian Biennale. In commenting on his art, he said, "I look at myself as an artist or better, an Aerosol Expressionist, not as a Graffiti Artist. Everyone can call it Graffiti, I don't mind, I know what I'm doing." He lived for a time in Verona, Italy. When he returned to the United States, the mayor of New York came to congratulate him on a mural he had done. (Courtesy of Claudette Clark Hutchinson.)

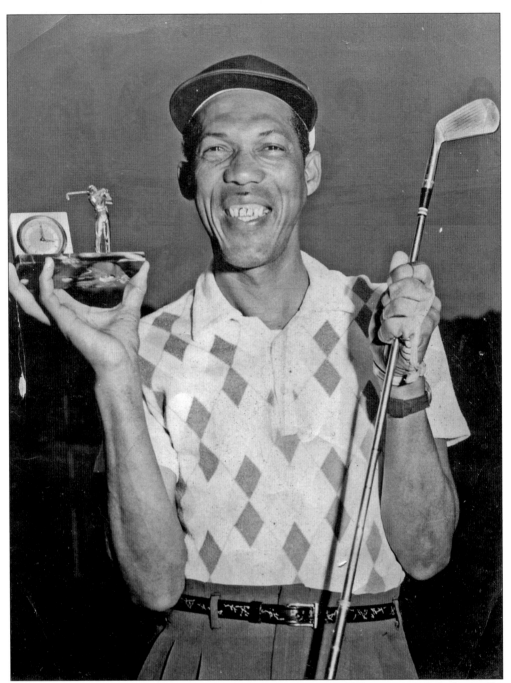

Mannie Clark Sr. wins best dressed at the Chitterling Circuit Golf Tournament in Jacksonville, Florida. Mannie was head caddy master at the Mayfair Golf Course in Sanford in the late 1950s. He was proud to boast that boxer Joe Louis was among the golfers he beat to win the award. Mannie is the father of eight children, whom he raised alone after his divorce. He lived on Lake Avenue (formerly Clark Avenue) in Goldsboro, in a home purchased by his parents, Nellie and Clarence Clark. He is not related to the town's founder, William Clark. (Courtesy of Claudette Clark Hutchinson.)

Daphne Crooms Duval (Williams) is pictured here at age 11 in 1917. (Courtesy of Sally Crooms Richmond.)

Daphne Crooms Duval Williams (seated) is the niece of Prof. Joseph N. Crooms. This is her 100th birthday celebration given by her two daughters, Daphne (right) and Sally Richmond (left). Students from the University of Central Florida filmed her birthday celebration, and it is included in the documentary *Goldsboro: An American Story* in the summer of 2006. She retired from teaching at Lincoln High School in Jacksonville. She was one of the first African Americans to desegregate the University of Florida. (Courtesy of Sally Crooms Richmond.)

Queen Esther S. Jones grew up in Oviedo and graduated from Crooms Academy in Sanford. She earned her Bachelor of Science degree in business education at Florida A&M University in Tallahassee, her Master of Science degree at the University of Central Florida, Orlando, and her educational specialist degree in computer science (K–12) at Nova University, Boca Raton, Florida. She served as president of the Seminole County Retired Educators Association. (Courtesy of Queen Esther Jones.)

Geralyn Jones, featured in this 1978 photograph, was born in Tallahassee to Rev. and Mrs. Amos C. Jones. She graduated from Seminole High School in 1979. She began a career with Martin Marietta (now Lockheed Martin Corporation) in Orlando, Florida, after graduating from high school. She was the first black woman to graduate from the University of Central Florida, with a degree in electrical engineering. She was a member of the Ballet Guild at the School of Dance Arts in Sanford, under the instruction of Miriam Rye Docktor and Valerie Weld. Geralyn married minister Robert L. Guy (a Sanford native), and they have two girls, Jazmyne and Jayelyn. (Courtesy of Queen Esther Jones.)

Rev. Amos Jones (1935–1997) attended Crooms Academy. He earned a bachelor's degree in biology and agricultural science at Florida A&M University. He received a master of divinity degree from Yale University in New Haven, Connecticut. He was installed as pastor of St. Paul Missionary Baptist Church in October 1977. Jones married Queen Esther Stallworth and had three children. He was a champion of civil rights. He received numerous awards for his professional and civic contributions. (Courtesy of Queen Esther Jones.)

Arlene was born in New Haven, Connecticut, to Rev. and Mrs. Amos C. Jones. She is a graduate of Seminole Community College. Upon graduation, she was employed and received excellent training in the insurance industry at Allstate Insurance Company. Arlene, a capable dancer, was trained at the School of Dance Arts in Sanford. Arlene loves music and is a gifted singer. (Courtesy of Queen Esther Jones.)

Alvin "Chris" Jones was born in Sanford to Rev. and Mrs. Amos C. Jones. He graduated from Seminole High School in 1986. Chris was a scholar-athlete and earned two athletic state titles while at Seminole High School—the long jump and the triple jump. He was also a talented baseball, basketball, and football player. He earned his undergraduate degree from Princeton University in New Jersey and his law degree from the University of Florida. He is currently a practicing attorney in Tampa. (Courtesy of Queen Esther Jones.)

"Mother" Sarah Floyd has owned and operated a barbershop on Thirteenth Street for over 40 years. After graduating from barber school, she mentored under Herbert Cherry. Patrons who frequent her shop leave with more than a haircut; they leave with words of wisdom. (Courtesy of EYESEEIMAGES.)

Here are members of Alpha Kappa Alpha Sorority, Inc. at Founders Day Celebration in 2002. From left to right are (first row) Carletha Merkerson; Rebecca Sweet; Vivian Hurston Bowden; and Juanita Graham Harold; (second row) Eddye K. Walden (chair); Dr. Lorraine Harris; Dr. Norma Solomon White, 25th international president; Dr. Geraldine Wright; Sandra Petty; and Valada Flewellyn, honorary member. (Courtesy of Eddy Kay Walden.)

This is the historic town hall meeting for the first Goldsboro documentary at the New Mount Calvary Baptist Church held June 7, 2006. From left to right are (first row) Eunice Wilson, Elmira Fields Hall, Robert B. Thomas, and Vicki Brown Smith; (second row) Adelle Wilson Baker, Dorothy T. Johnson, Henry Talton, and Irma Copper; (third row) Johnny and Joella Singleton; (fourth row) Willie King Sr. Present but not pictured were Kenneth Bentley, Rufus Brooks, Mary Hayes, Cheryl Nicholas, Annie O'Neille, Thelma Mike, Dr. Connie Collins, Marva Hawkins, Jim Robison, Edward Blacksheare, Yvoonne Brooks, Mary Hayes, Toni Adams, David Koster, and Rev. Valerie Henry. The film *Goldsboro: An American Story* is housed in the Zora Neale Hurston Institute of Documentary Studies archives at the University of Central Florida library. (Courtesy of EYESEEIMAGES.)

Farmers Named To Conference

Three Sanford area farmers have been named delegates to the Governor's Conference on the Future of Small Farms to be held Oct. 30-Nov. 1 in Ocala, Lt. Governor Wayne Mixson announced.

Invited to participate on the recommendation of County Agricultural Extension Agent Frank Jasa, were Margaret Tucker, Bruce Cepuran and Ezekial Dixon.

Agriculture is vital to the continued economic success of the people of our State and the small farm is essential to the stability of the agriculture community," Mixson said. "Governor Graham and I look to this Conference to provide direction to state government in the 1980s relative to our encouragement of the existence and growth of the small farms in our State."

"I am looking forward to the insight and sense of direction that we will receive from the 250 delegates we are asking to the meeting," Mixson said.

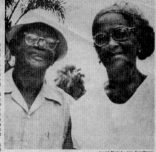

Herald Photo by Jane Casselberry

Ezekial "Zeke" and Irene Dixon — their 'roots' are in the soil.

'Zeke' To Share His Secrets For Small Farm Success

By JANE CASSELBERRY
Herald Staff Writer

"Know what you're doing and do all you can" — that's the formula for successful farming espoused by Ezekial "Zeke" Dixon of 1910 W. 13th St., Sanford.

Zeke, who will be 76 Oct. 19, is still bullish on America and the merits of hard work after 35 years of scratching a living from the soil.

Named one of three Seminole County delegates to the upcoming Governor's Conference on the Future of Small Farms, Zeke can tell plenty about running a small farm.

The Farmers Home Administration got the benefit of Zeke's common sense and experience when he served last year on the county committee that makes loan recommendations. His term expired in June.

He and his wife of 57 years, Irene, 72, still raise a variety of vegetables year round on the two acres behind their home, but they lease their other five acres of farmland on West First Street. Their youthful energy and enthusiasm belies their age.

Most of the vegetables they grow are sold from their house, while the rest are sold to the produce market at the Sanford Village Flea Market, they said.

"I've learned what it takes to stay in the business," said Zeke, "and from

experience I've seen that greed will kill you."

Born in Taft in 1905, Zeke's mother died in childbirth, so he never knew her. When his father remarried he was raised by his stepmother.

A third-grade dropout, Zeke says he was a "kid who was paid not to go to school."

"I had to work so I went to work in the fields," he said. "What I know I know from experience. That way some times you get knocked over the head."

Irene, who was born in Lake City met Zeke when her parents were working as farm laborers in Sanford. She was only 16 when they were married.

"I had $2.50 in my pocket when we got married," Zeke said, "and the marriage license cost $1.50. A friend let me have the money for the license."

"We were married at 7:30 in the morning and I cooked his breakfast afterwards," Mrs. Dixon recalled.

Before buying his own farm, Zeke worked for 20 years for celery grower Otto Schmehl.

Zeke and Irene raised six children and it wasn't easy, they said. During World War II Zeke was called before the local draft board.

"When they learned I sup... my wife and six children... they said it would cost... lot more to do it if I...

could serve better by staying where I was," Zeke said.

"When I went into farming we kept our kids in school and they didn't have to drop out to work in the fields," Zeke said. "They all finished high school. Two of my daughters went to college and earned their master's degree. One teaches in Lake County and the other in Maryland."

All of the Dixon children, now between 47 and 55 years old, have moved away from Sanford. The youngest daughter died a year ago. One son, retired after 20 years in the Armed Forces, is now a television technician as is a second son. They own their own businesses. A fourth daughter operates a nursing home in Ft. Pierce.

"I raised my children to be an asset to the community, not a liability and, thank God, everyone of them has grown up to be an asset," Zeke said.

The Dixons also have 15 grandchildren and several great-grand-children.

Only once was it necessary for the Dixons to accept welfare.

"I was sick and wasn't able to work and support my family, so my employer, Mr. Schmehl, arranged for me to get help from the welfare," said Zeke. "As soon as I felt better I sent my wife down to tell them we appreciated the help, but I had gotten to where I felt we could go on our

See 'ZEKE', Page 12A

This is a 1981 article from the *Sanford Herald* when Zeke Dixon was one of three Sanford-area farmers to be selected as a delegate to the Governor's Conference on the Future of Small Farms. It features Zeke with his wife, Irene. Zeke was born in Taft, Florida, in 1905. The Dixons sold most of the vegetables they grew from the home at 1910 West Thirteenth Street. According to Irene, their home was the first two-story home built in Goldsboro. Zeke built the home himself. (Courtesy of Royce and Eddye Kay Walden.)

Irene Dixon is pictured at her dining table sharing her photo albums with author Valada Flewellyn. She was born April 12, 1908, in Lake City; she was a homemaker and a member of First Shiloh Missionary Baptist Church. She passed away on November 29, 2001, at the age 93. (Courtesy of Valada Parker Flewellyn.)

It is Christmas 1950, and the three Coleman sisters pose with their new toys, Jeanette (called "Pink") in the wagon, Francis on skates, and Claudia on her new bicycle. They are the children of Levi and Wilma King Coleman. They are outside their home at 1112 West Ninth Street. (Courtesy of Francis Coleman Oliver.)

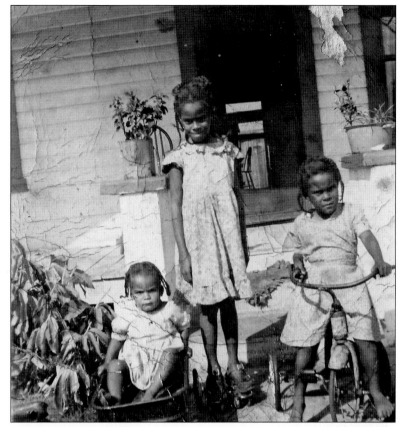

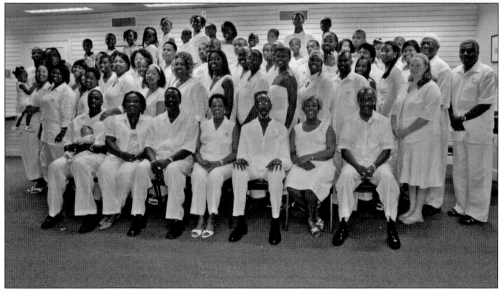

This is the Merthie family at the 2005 family reunion. In the first row are the siblings, seated from left to right: Lyndon Bernard Merthie holding granddaughter Lateren, Marilyn Martin, Pastor Ronald Merthie, Linda "Judith" Israel, Oscar Merthie Jr., Lillian Hamilton, and Willie Merthie. Ronald Merthie is pastor of the New Life Word Center in Sanford. (Courtesy of Marilyn Martin.)

Ronald Nathan was principal of Goldsboro Elementary for years before moving to the brand-new Altermese Bentley Elementary School. The school is named for Sanford's well-known local historian. Nathan was born in Sanford, graduated from Crooms Academy, and is a gifted musician. He is married to Ingrid Burton Nathan, and they have three daughters. (Courtesy of the Sanford Herald Collection, Sanford Museum.)

This group of concerned citizens gathers after a meeting regarding the preservation of Crooms Academy, which was threatened and in danger of being closed. They worked successfully, taking legal measures to save the school. They continue to work, led by former Crooms principal Edward Blacksheare, in an effort to preserve the history of Crooms and to maintain it as a vital part of the Sanford community. Shown are, from left to right, (first row) Alder Craig, Katheyrn Alexander, and Bennie Alexander; (second row) Edward Blacksheare, Lewis Jones, and attorney W. George Allen. (Courtesy of the Sanford Museum.)

This is a meeting of the Crooms class of 1963 at the home of the class mother, the late Shupelia Barrington (center). Pictured are, from left to right, Sheralyn Darnell Jackson Brinson, Mary Emma Stringer Harkness, Loretha Benjamin Carpenter, Dorothy Taylor Webster, Pamela Elaine Walker Byrd, Elizabeth Laverne Hatch Graham, Gloria Jean Smith Rollins, Freddie Lee Barrington, Agnes Wilson Leonard, Hilda Delores Bass McNeill, and Ora Lee Harrison Alexander. The person behind Elizabeth Graham is unidentified. (Courtesy of the Sanford Herald Collection, Sanford Museum.)

Pictured here are King Virgil Scott, his wife, Euler, and their five children, from left to right, Eartha, Cordell, King Jr., Eva, and Kenneth. The Scotts' eldest child, Eartha, was born on the John Lovett farm in Sanford. The Scotts came to Sanford in the early 1930s. King Scott worked for Chase and Company as a foreman. The Scotts' family home is at 1608 South West Road. (Courtesy of Eartha Scott Joseph.)

LifeStyle

Marva Y. Hawkins rides in a carriage during a parade held last Saturday in her honor.

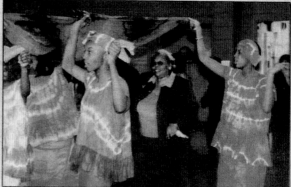

Photos courtesy of Toya Flewellyn of eyeseeimages/page layout by Michelle Jerla
Students from Tajiri School lead Marva Hawkins into the reception held at the Girls and Boys Club.

Marvelous Marva

Community journalist, activist honored by her friends, family and peers

By Michelle Jerla
Managing Editor

Marva Y. Hawkins thought she was going to Orlando last Saturday to attend a religious conference. Friends and family, however, had other plans for the Goldsboro resident.

Early in the morning, Hawkins was told she was the guest of honor for Tajiri School of Performing Arts and Academics' History Still/History Alive celebration. She was greeted at her door by a horse and buggy, which she rode during a parade held in her honor.

"I was thoroughly surprised by it all," Hawkins said. "I knew that they were going to have a parade, so I wanted to

Hawkins was long overdue. For more than 30 years, the journalist has recorded local history in her weekly column and has been an active member of the community. Her list of accomplishments and achievements is long, and she has been honored by numerous organizations that she has been involved with throughout the years.

Today, she is still a community activist and is a member of St. John Metropolitan Baptist Church, the Agriculture and Labor Program Inc. (ALPI), Crooms Academy Class of 1950 Reunion Committee, the Central Florida Chapter of the International Black Women's Congress and Evergreen Temple No. 321 Order of Elks. She is also an honorary member of the Gaines-Morgan AMVETS Auxiliary.

She has also played an integral part in creating the Goldsboro Front Porch Council Inc. Last year, she served as the organization's chairman and currently she is coordinator for its Elderly Program.

"When the committee was thinking about what person we could honor, her name was brought up over and over again," Whatley said. "And, what better person could be chosen?"

Marva Y. Hawkins is featured in the headlines of the *Sanford Herald*. The community came out to pay tribute to her for over 40 years of reporting on the family, church, civic, and social activities in the African American community. Her parents, Anderson and Bessie Hawkins, owned a store on Thirteenth Street. Marva played in the Crooms Academy band. She graduated in 1954. Marva was a 2007 nominee for the Onyx Award. She received the Heritage Jubilee Distinguished Service Award from African American Cultural Form and many other awards and recognitions. She is active in a number of community organizations, like Gov. Jeb Bush's Front Porch Initiative, where she was the first board chairperson. (Courtesy of *Sanford Herald*.)

Five

PANTHER PRIDE

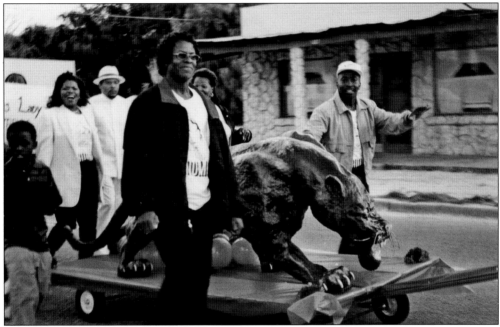

This is a photograph taken during a Crooms High School Reunion Parade, which was sponsored by the Crooms High School class of 1963. The reunion president is Sheralyn Brinson; the lady in the white jacket is Sylvia Brinson Graham. Graduates of Crooms Academy are extremely proud of their school for its exemplary history of bringing communities together. The school's founder, Joseph N. Crooms, his wife, and daughter, along with all of the former principals, teachers, staff, and students, all have treasured memories of their days at Crooms Academy where they were taught to value education. The rewards of that lesson have enriched communities throughout the United States and abroad where Crooms' Panthers have lived, worked, and made tremendous contribution as philanthropists, volunteers, and good citizens. Many return to Sanford to live or to visit. Most agree that their experiences in Sanford have made a marked impression on their lives. May the legacy of the Mighty Panthers live forever. (Courtesy of the Sanford Herald Collection, Sanford Museum.)

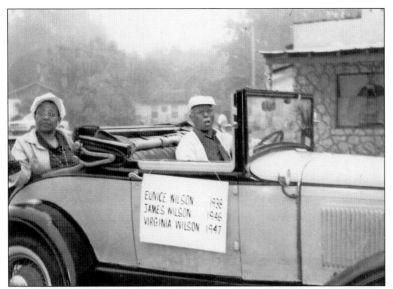

James and Virginia Wilson participate in the Martin Luther King parade down Thirteenth Street. The sign on the door lists three members of the family and the dates they graduated from Crooms Academy: Eunice in 1938, James in 1947, and Virginia in 1949. (Courtesy of James and Virginia Wilson.)

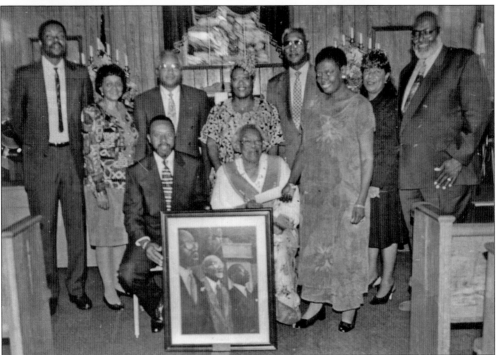

The Brewer family presents a portrait of Rev. Castle Brewer to St. Paul Church and Education Committee representatives Earl Minott and Altermese Bentley (center) at the annual Castle Brewer Scholarship Day in December 1998. Rev. Castle Brewer was pastor of St. Paul Missionary Baptist Church from 1884 to 1936. In 1950, the Sanford Housing Authority named a 125-bed unit housing project Castle Brewer Court in recognition of his community leadership. Bentley was director of Christian education at St. Paul. From left to right are (first row) David Robinson; Altermese S. Bentley; and unidentified; (second row) Charles Gray, a descendant of Castle Brewer; Deloris Myles; Victor Dargan; Sherlyn J. Brinson; Earl E. Minott; Barbara Kirby Bentley, and unidentified. (Courtesy of the Sanford Herald Collection, Sanford Museum.)

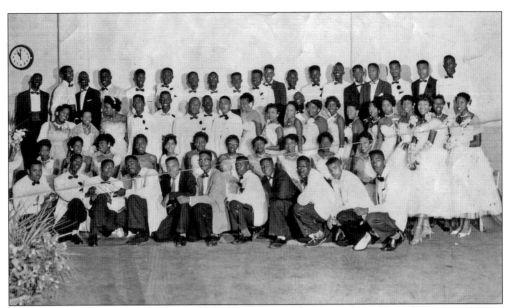

The Crooms Academy junior prom is pictured in 1957. (Courtesy of the class of 1957.)

Jeff Bertrand Coleman Blake is pictured signing autographs for his hometown fans. Jeff is a graduate of Seminole High School in Sanford. He played in the National Football League with the New York Jets, Cincinnati Bengals, New Orleans Saints, Baltimore Ravens, Arizona Cardinals, Philadelphia Eagles, and Chicago Bears. In college, he finished seventh in the 1991 Heisman Trophy voting. He was inducted into the East Carolina Hall of Fame in 2007. (Courtesy of the Sanford Herald Collection, Sanford Museum.)

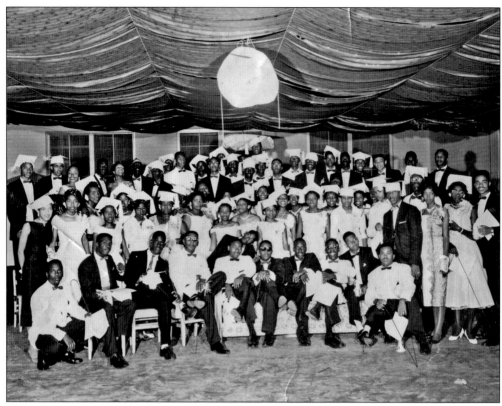

Shown here is the Crooms Academy class of 1957 senior prom. (Courtesy of the class of 1957.)

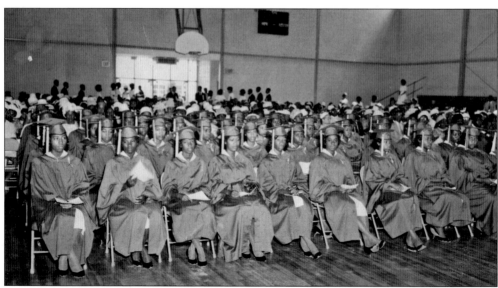

This is the Crooms Academy class of 1962. The president of the alumni association is Harry Harvey. Willie "Pocket" Brown took this photograph. (Courtesy of Willie "Pocket" Brown family.)

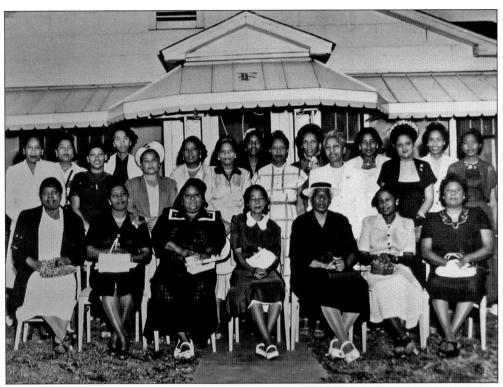

Sanford African American retired teachers are pictured here in the 1950s. (Courtesy of Royce and Eddye Kay Walden.)

Bob Thomas was the first African American elected as a city commissioner for the City of Sanford in 1984 and served until 1996. He was born in Sanford and graduated from Crooms Academy after returning home from the service in 1951. He went on to finish his education at Florida Agricultural and Mechanical University in 1959. He worked as a truant officer with the Seminole County Public Schools. He was instrumental in organizing the first Dr. Martin Luther King Jr. Commemorative Celebration for the citizens of Sanford. (Courtesy of the Sanford Herald Collection, Sanford Museum.)

Oswald Brunson Sr., Ph.D., is an alumnus of Bethune-Cookman College. He served as the fourth president of the college from 1975 to 2004. He was raised in Midway and is a graduate of Crooms Academy. (Courtesy of EYESEEIMAGES.)

Rufus Brooks graduated from Crooms Academy in 1938. He moved from Goldsboro to Orlando and was principal of Eccleston Elementary and Wheatley Elementary in Orlando and the Hungerford Elementary School in Eatonville. He served as president of the Orange County Branch of the NAACP from 1986 to 1990. He is a second-degree mason, Shriner, a member of the Rotary Club, and a member of many other philanthropic organizations. He is a civil rights activist and marched in St. Augustine with Martin Luther King. He is married to Edith Brooks, and they have three very successful children. (Courtesy of Rufus Brooks.)

Frances Coleman Oliver (right) shares a historical artifact of Sanford with Ollie Williams (left), Betty Robinson, and Elaine Crumity inside the classroom, in Hopper Academy, that holds her rich collection of Sanford memorabilia. Francis grew up in Sanford before the civil rights movement, when as she remembers, "The houses were mostly shotguns with outdoor toilets, no running water or heat." She enjoys sharing the stories of her childhood and collecting and sharing the items that will preserve the history of Sanford's black community. (Courtesy of Valada Parker Flewellyn.)

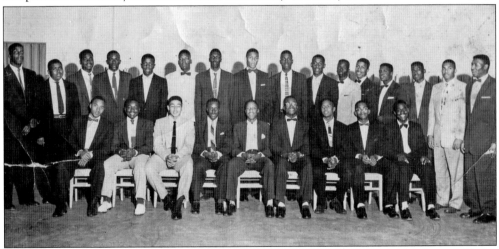

The Crooms Academy football team of 1956–1957 included, from left to right, (seated) Victor Dargan, Julius Johnson, Eddie Lanier, Samuel Nesbitt, Joseph Walden, L. J. McFadden, Clarence Lancaster, Bernard Lomax, and Joe Cain; (standing) coach Helburn Meadows, Fat Long, Otha Abney, Anthony Brown, Morris Thomas, Nathaniel Straws, Lonnie Hardy, Addis Lamb, Robert Black, Ralph Thomas, Grady Robinson, Melvin Ruth, Paul Knight, Thomas Wright, coach Edward Blacksheare, and head coach Joe Fair. (Courtesy of Victor Dargan.)

Timothy "Rock" Raines was born to Ned and Florence Raines in Sanford in 1959. He is a former left fielder in Major League Baseball. He played for six teams from 1979 to 2002 and was best known for his 13 seasons with the Montreal Expos. He is regarded as one of the top leadoff hitters and base runners in the sport's history. His parents live in the green three-bedroom clapboard house on Airport Boulevard that Tim grew up in. There were seven children. His father worked for the same construction company for 26 years. Ned Raines also played semipro baseball with the Sanford Giants until he was 34 years old. Two of Timothy's four brothers played minor-league baseball, Levi and Ned III. Timothy married his wife, Virginia, in 1979, and they have two boys, Tim Jr. and Andre "Little Hawk." There is a display of Tim Raines memorabilia at the Sanford Museum. (Courtesy of the Sanford Museum.)

Charles Hayward Merritt Jr. (1938–2003) is the son of Charles Hayward and Julia Rae Merritt. His sister Patricia Rae Merritt Whatley is the founder of the Tajiri School of Arts. Charles graduated from Crooms Academy High School. He was a nationally known and respected radio personality in Jacksonville known as "The Mad Hatter." (Courtesy of Patricia Merritt Whatley.)

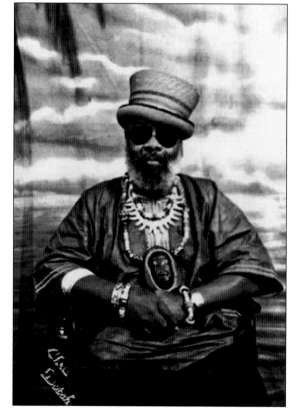

Dr. Velma H. Williams gives visitor Cherry Byrd (left) from Chicago a tour of the Velma Williams Resource Center on Thirteenth Street in Goldsboro. Velma is the daughter of Arthur and Eldora Hayes. Her grandmother, Mamie Dinah, raised her. She graduated from Crooms Academy in 1959. She was very active at Crooms. She was captain of the cheerleaders, a majorette, Miss Homecoming, and Miss Crooms Academy. She worked in many education positions at area universities and colleges as well as in the public school system. She was elected to the Sanford City Commission for District 2 in 1997 and reelected in 2001. She was the first woman elected and the first African American elected to the Sanford City Commission. In 2003, Velma was appointed vice mayor, the first African American to hold that position. She is married to M. Sgt. Edgar Williams and has two children—Eric, an electrical engineer, and Vashaun, a medical doctor. Velma is a member of Allen Chapel African Methodist Episcopal Church. (Courtesy of EYESEEIMAGES.)

Judge James Perry is the first African American judge in Seminole County, and he was unanimously voted chief judge of the 18th District, another first. In March 2009, James Perry was appointed by Gov. Charlie Crist as the fourth black justice to the state Supreme Court. (Courtesy of the Sanford Herald Collection, Sanford Museum.)

Mary L. Jackson Fears, a retired Volusia County school media specialist, graduated from Bethune-Cookman College and Florida State University. After having earned a bachelor's degree and a master's in library and information science, she has become a professional storyteller, genealogist, and author of four books: *The Jackson-Moore Family History, Slave Ancestral Research, It's Something Else, Civil War, Living History Reenacting About People of Color,* and *Julie's Journey,* an inspirational memoir about the author's daughter, Julie LaVera Anderson. Mary is also the producer of the docudrama *Filling the Gap,* a film that features little-known facts about people of color during the antebellum period in America. This 1994 photograph was taken at Montsho, the first black bookstore in Central Florida, owned by Jackie Perkins. (Courtesy of Valada Parker Flewellyn.)

These are the ushers at New Bethel Missionary Baptist Church. From left to right are (first row) Elizabeth Mitchell and Nellie Jones; (second row) Catherine Smith, Margaret Alloway, Sylvia Bodison, Jessie Mae Davis, and Helen Smith. (Courtesy of the Sanford Herald Collection, Sanford Museum.)

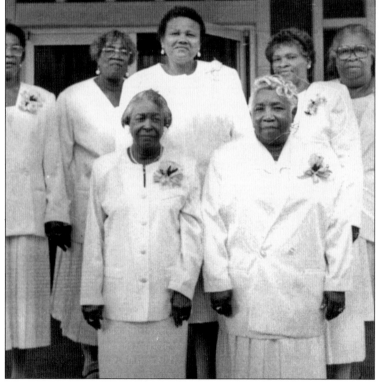

Dr. Willie and Patricia Sherman are shown with a guest at the 2006 Crooms Academy reunion for the class of 1961–1962 at the school. From left to right are Lucille O'Neal, Patricia Sherman, Henry Gordon, Dr. Willie B. Sherman Jr., and Judy Walker. Dr. Sherman was born in Sanford; he is a dentist and has offices in both Sanford and Orlando. (Courtesy of EYESEEIMAGES.)

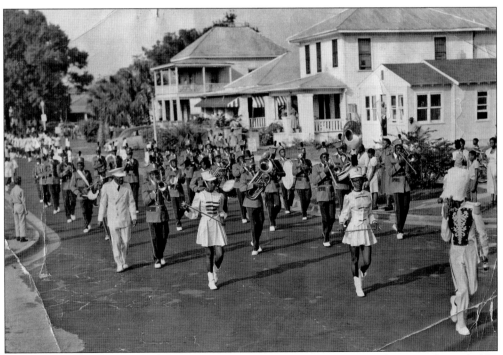

The Crooms Band marches proudly down Sanford Avenue in their brand-new uniforms, led by drum major Clifford Hurston Jr. (nephew of well-known author Zora Neale Hurston) in 1956. (Courtesy of Dr. Clifford Hurston Jr.)

Court jesters Jeremy George and Robert Guy opened, and were the announcers for, the Young Performers of Tajiri Arts 1996 presentation of "An Evening with William Shakespeare and Paul Laurence Dunbar," at Dr. Phillips Center for the Performing Arts, Orlando, on March 31, 1995. The program was written and directed by Patricia Merritt Whatley and Levather Whitby. The Orlando Opera Children's Chorus with director Robin Jensen partnered with Tajiri on this project. Other musical directors were Sandra Petty, Gloria Williams, and Eloise George. Featured in the program as legendary guest artists were jazz greats Jesse Stone and Evelyn McGee Stone, along with television and Broadway star Harry Burney and New York entertainer and choreographer Alton Lathrup (both from Sanford). Robert Swedberg was the executive director of the Orlando Opera Company. (Courtesy of the Sanford Herald Collection, Sanford Museum.)

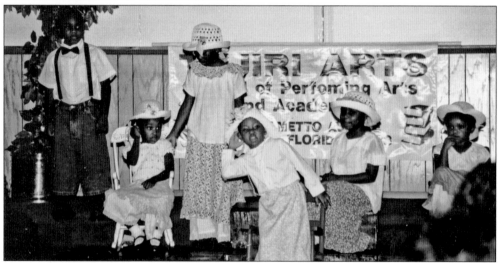

The young performers of Tajiri Arts School of Performing Arts are dressed in early-19th-century costumes during an African American Heritage Tour at Macedonia Missionary Baptist Church in Eatonville. The 2001 event was part of the Alpha Kappa Alpha Sorority, Inc., induction ceremony, where author/poet Valada Parker Flewellyn became only the second woman from Florida to receive honorary membership into the group. Pictured from left to right are Steen Charles, Amira Manes, Kanya Moore, Deja Hunt, and Hahmaria Mullins. Karen Moore is the young girl sitting in the chair at the bottom of the steps. Tajiri Arts founder Patricia Merritt Whatley sang a Negro spiritual to introduce the children's performance of a skit based on Flewellyn's children's book *The Mosquito*. Flewellyn presented her poetry to the group, including "The Mosquito of Orange and Seminole County," a poem she wrote to commemorate the 85th anniversary of Seminole County. (Courtesy of EYESEEIMAGES.)

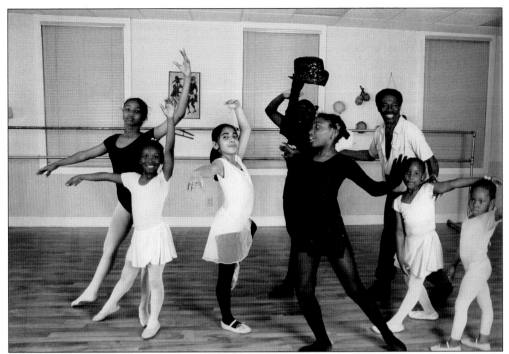

Here is a 2004 dance class at the Tajiri School of Performing Arts with instructor Alton Lathrop. Lathrop is a Sanford native who returned home to take care of his mother after dancing in New York and traveling across the country as the lead dancer in *Bubbling Brown Sugar* with Cab Calloway. (Courtesy of Toya Flewellyn.)

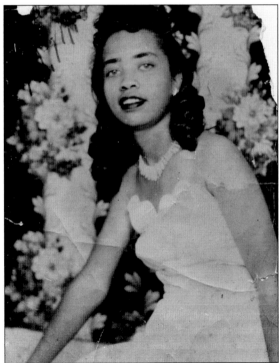

Martha Hall (Doctor) is dressed for her senior prom in 1952. (Courtesy of Martha Hall Doctor.)

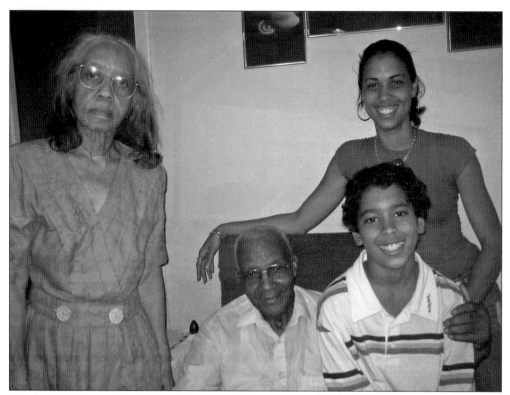

Martha Hall Doctor, Rev. Robert Doctor, and their two grandchildren are pictured in their home in Georgetown. Reverend Doctor has pastored three churches in Sanford: St. Paul Baptist (1966), New Bethel Baptist (1979), and St. John Baptist (1989). (Courtesy of EYESEEIMAGES.)

Annie S. O'Neille was born in Sanford to Boise and Frances Stokes. She graduated from Crooms Academy in 1945 and Florida Agricultural and Mechanical School for Negroes. She initiated a tutorial program at Goldsboro Elementary School, which has spread throughout schools in the county. She has won numerous awards for voluntary service. She is married to Willie O'Neille, and they have four children. She is a member of Allen Chapel African Methodist Episcopal Church. Annie shared the following information about herself: "I was born on the South West Road on the corner of 16th Street. My parents moved there when I was quite young. They bought and built on the present site where I am now living in the same house that was built in 1927. There were ten children living in a six-room house. All ten of us went across the street to the 'Little Red School' which is now Goldsboro Elementary." (Courtesy of the *Sanford Herald*.)

Members of the Zion Hope Missionary Baptist Church were honored for their service at the annual Appreciation Luncheon in 2008. Those honored were Deacon Fred E. Brooks Jr., a member for 33 years; Cleo "Miss Cleo" Alexander Burton, a member for 67 years (she has been a cosmetologist in Sanford for 63 years and a member of Evergreen Temple No. 32 for 50 years); Deacon James Carter Jr., 50 years; Sarah Fields, 37 years; Willie Agnes Riggins Knighten, 67 years; Rebecca Henderson, 71 years; Thelma Hopson; Fred Peck, 14 years; Arthur Hill; Jerome Harper; Dorothy Gaines Smith; and the late Clifford C. B. Pringle. The chairperson for the event was Katrina Caldwell Davis. (Courtesy of the *Sanford Herald*.)

Pictured from left to right are Sanford Elks Club members (first row) Pearlie Mae Ford, Grace Melton, Curtistine Peterson, Hattie Lee-Davis, and Ruby Nathan; (second row) Gail Ford-McQueen, Lula Cummings, Gloria Flournory, Carletha Merkerson, Sylvia Bodison, Katie Burke, Clarence Ford, and Robert Huntley. (Courtesy of the Sanford Herald Collection, Sanford Museum.)

Ingrid Burton was the first black student to integrate all-white Sanford Junior High School in 1965. She is a teacher at Lake Mary High School. Ingrid shared her concern that today's schools do not provide black children with the support that existed during segregation, when black teachers were part of the community and kept in contact with parents. She is married to Ronald Nathan. (Courtesy of the Sanford Museum.)

Ricardo "Ricky" L. Gilmore was among first black students to integrate Seminole High School in 1970. In spite of the difficulties that arose around the transition from segregated schools, he managed to navigate the new environment. He was so well liked by his peers, black and white, that he was elected senior class president, quite a feat in a very volatile time. Ricky grew up on Celery Avenue. He is a partner in the law firm Saxon, Gilmore, Carraway, Gibson, Lash, and Wilcox, Practicing Attorneys in Tampa, Florida. (Courtesy of the Sanford Museum.)

These three ladies are Gertrude Jenkins (left), Retha Sheppard (center), and Eveline Colloway in 1995. (Courtesy of the Sanford Herald Collection, Sanford Museum.)

Ella Dinkins is the daughter of Addie Mae Gramling. Her mother was the only child born to Oscar and Ella Stone Gramling. Oscar Gramling was the proprietor of a barbershop whose clientele was exclusively white. He owned one of the few houses in Sanford with indoor plumbing. Ella attended Crooms Academy through eighth grade and went to Atlanta University to complete high school and teacher training. She grew up on Cypress Avenue and now lives in Eatonville. She is the mother of N. Y. Nathiri, the founder and director of the Annual Zora Neale Hurston Festival in Eatonville. She is pictured here signing a book that she is featured in: *A Conversation With the World: Eatonville*. This book signing was at the annual festival town hall meeting in 2008. (Courtesy of EYESEEIMAGES.)

The historic Stokes Fish Market on Sanford Avenue in Georgetown became the site of the campaign office for presidential candidate Sen. Barack Obama and vice presidential candidate Sen. Joe Biden in 2008. (Courtesy of EYESEEIMAGES.)

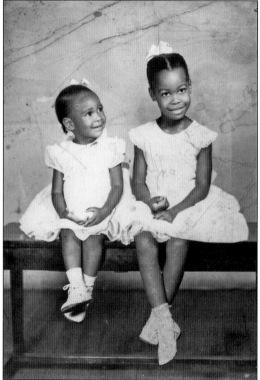

The little girl on the right grew up and became fascinated with Sanford's history. This is a photograph of author Valada Parker Flewellyn, age six, and her sister Willetha "Toni" Carter, age three, now a Ramsey county commissioner in St. Paul, Minnesota. A picture similar to this one drawn by artist Seitu Ken Jones appeared on Valada's first book cover, *Poetically, Just Us*. They are the daughters of the late Willie Tim and Cinda Parker. (Courtesy of Valada Parker Flewellyn.)

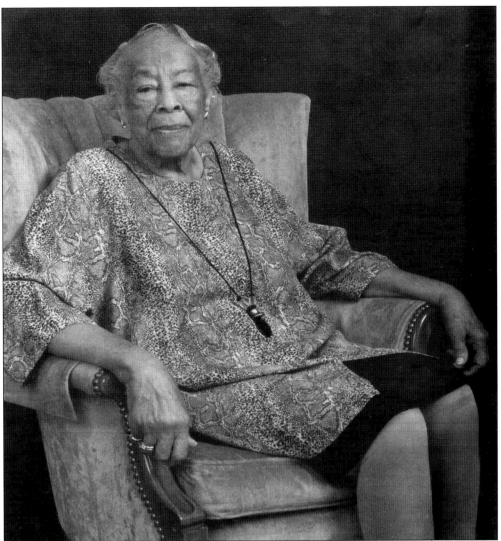

Altermese Smith Bentley was the daughter of Rev. Charles and Chaney Burnett Smith. The Smiths had three daughters: Eunice, Altermese, and Jerusha, who died at 13 months old. Bentley's maternal grandparents, Smith and Susan Burnett, had two daughters, Mary and Chaney. Grandfather Burnett was a city employee and worked as a trash collector and lamplighter. The Bentley sisters inherited the property on Ninth Street between Pine and Hickory Avenues in Georgetown, which was bought by their grandparents, Smith and Susan Burnett, in 1882. The land was low and flat with a stream running the length of the property; to help fill and bulk up the land, he hauled all of the debris and trash he collected and dumped it as landfill. He succeeded in developing a home site. Altermese Bentley lived away from Sanford for many years but returned to live in that house and to collect the rich history of her beloved hometown. She wrote the first book about Georgetown, then an Arcadia Publishing book about Seminole County as well as other articles and publications. Bentley has received many honors for her dedication to area history. A park in her neighborhood and a newly built Seminole County Public School were named after her. She had the pleasure of being present at the ground-breaking ceremony for the school. Although Altermese Bentley is no longer with us, the rich legacy she has left will be with us forever. She is a real hometown hero. (Courtesy of Altermese Bentley Elementary School.)

Across America, People are Discovering Something Wonderful. Their Heritage.

Arcadia Publishing is the leading local history publisher in the United States. With more than 5,000 titles in print and hundreds of new titles released every year, Arcadia has extensive specialized experience chronicling the history of communities and celebrating America's hidden stories, bringing to life the people, places, and events from the past. To discover the history of other communities across the nation, please visit:

www.arcadiapublishing.com

Customized search tools allow you to find regional history books about the town where you grew up, the cities where your friends and family live, the town where your parents met, or even that retirement spot you've been dreaming about.